Ellsworth Kelly

Ellsworth Kelly

Drawings, Collages, Prints

Diane Waldman

A Paul Bianchini Book
New York Graphic Society Ltd.
Greenwich, Connecticut

First published in Switzerland by Paul Bianchini S.A., Lausanne.
First published in U.S.A. by New York Graphic Society Ltd.,
Greenwich, Connecticut.
Library of Congress Catalogue Card Number 74-160820.
Standard Book No. 8212-0382-7.
Manufactured in Switzerland by Imprimeries Réunies S.A.

Contents

This is the third in a series of books on Contemporary American Artists.

The drawings and collages reproduced here represent a selection
of the most significant works from 1949 through 1970.
Many of these works were conceived as studies for specific paintings,
whose titles will appear in capital letters within the captions.
Those drawings and collages which measure less than 8¼ inches in height
and 10½ inches in width, have been reproduced in their actual size.
Color separations have been made directly from the original
works, with the following exceptions: collages Nos. 48, 58, 59, 70, 141.

The catalogue of prints is complete for the period 1950-1970, and has
been arranged in the following sequence: single editions, lithograph suites,
and posters. Captions denote the colors of the various images which
read either from top to bottom, or from left to right.
A number appearing in parentheses indicates the number of a print
within a lithograph suite. In all cases, the full sheet of each print has been
reproduced and the dimensions given refer to the size of the full sheet.

I wish to thank Ellsworth Kelly, who has dedicated so much of his time
to the preparation of this book, also Henry Persche, Kenneth Smith,
Anne de Turgis, Galerie Maeght and Gemini G.E.L., for their assistance.

Paul Bianchini

Introduction

Ellsworth Kelly's emergence as a major figure of vanguard American painting has been gradual, and has come about largely without benefit of publicity or notoriety. The cult of the public personality adopted by some of his more flamboyant contemporaries is alien both to his temperament and to his art. If the belated recognition of his gifts as an artist can be partly attributed to his lack of interest in self-aggrandizement, it is also the result of his method of working—a cyclical and reflective procedure that is in almost complete contradiction to current practice. As a consequence, only a fraction of his total body of work is generally known, and that fraction stems mostly from the late fifties to the mid-sixties, giving a distorted perspective of his activities. Although his career spans more than twenty years, Kelly is, in this sense, still an undiscovered artist. However his public image may have suffered, his relative neglect and isolation have made it possible for him to keep extending his multi-faceted work to its fullest potential. Though this leisurely approach may not meet the requirements of fashion, it has allowed him to produce major innovations in his painting and in his sculpture and drawings as well.

Kelly's work has suffered not only from insufficient exposure but also from the need of most critics to classify art as part of common thought processes. By side-stepping identification with a particular group or school, more a matter of instinct than intent, Kelly has often been misinterpreted and his work confused with issues with which it has only a tangential relationship. Early in the sixties his work was categorized as Hard Edge painting despite the fact that his concern is not primarily with edge; as he has explained: "I'm interested in the mass and color, the black and white—the edges happen because the forms get as quiet as they can be." [1] Shortly afterwards, his work was confused with the optical painting then in vogue; more recently, it has been associated with systems and with working in series. But he does neither, at least not as a consistent practice. These passing affinities, which do indicate certain peripheral issues encountered from time to time in his work, have little to do with the core of his thinking. Unlike Lichtenstein and Noland, whose work raised specific and timely issues that coincided with the interests of other artists, Kelly has remained a singular figure, touching mainstream thinking largely when it coincided with his own. Like Lichtenstein and Noland, who have been misrepresented because of their classification with a faction or group in the sixties, Kelly represents the uniqueness of the individual sensibility, his work testifying not to the importance of a particular school or in service to a doctrinaire "modernism" but constituting an affirmation that art has no rules, no systems—only possibilities.

In this respect, Kelly disputes current attitudes about art. His decisions, keyed as they are to the uniqueness of the individual painting—an approach very much out of favor during the sixties but beginning to reappear in the work of younger painters of the seventies—align him more closely with Johns or Rauschenberg for example, than with either Lichtenstein or Noland. He has been able to open up an area of art that cannot be determined solely by deductive reasoning, one subject to the discipline of a highly developed intuition and visual intelligence. It is perhaps this aspect of his art more than any other that has recently proven

influential to a younger generation of painters. Unlike many of the artists who came to prominence during the sixties, Kelly is committed to a felt decision about the final placement of vertical and horizontal, curve and diagonal, the choice of color and its intensity, and the relationship of one color to its possible partner or partners. While it is true that Kelly does predetermine certain of his decisions—the shape of the canvas support, for example—this too, is a matter of predilection rather than doctrine and is subject to change. In this respect, Kelly differs fundamentally not only from sixties artists but also from the Abstract Expressionists, for whom the blank canvas functioned as a void from which they brought into being a series of images that took shape as the result of near-mystical confrontations. The metaphysical aspect of fifties paintings does not figure in the work of artists like Kelly, Johns or Rauschenberg, all of whom were well into their mature work at that time; it was replaced by the "reality" that the canvas itself, as a literal object, suggested. It was Kelly's fundamental contribution to the art of the fifties and sixties to further advance this "reality" by proposing a new "reality" of color. The key to an understanding of Kelly's procedure as well as his intent is the large body of drawings, collages and prints he has produced from 1947 to the present.

> I work from drawings and sometimes collage; the drawings always come first and then collage later because it's easier to think about color that way. I usually let them lie around for a long time. I have to get to really like them. And then when I do the painting I have to get to like that too. Sometimes I stay with the sketch, sometimes I follow the original idea exactly if the idea is solved. But most of the time there have to be adjustments during the time of the painting. Through the painting of it I find the color and I work the form with it and it adjusts itself. [2]

From the very first, Kelly's drawings and collages have been the means by which he could best formulate his ideas. Far more than just the concept, however, is revealed in this body of work. Although never intended as finished pieces, they are generally conclusive enough to stand on their own as a comprehensive group. Even the smallest, almost thumbnail sketch, has a completeness that makes it possible for one to grasp Kelly's intention vis-à-vis his painting. And since he has produced many more sketches than he has paintings, they are of further value in allowing us to understand how the reasoning that went into the preliminary studies was different from the final process of elimination and selection that took place when it came time to do the paintings.

Kelly studied at the Boston Museum School from 1946 to 1948, after serving in the United States Army from 1943 to 1945. While in the army he developed a passion for Romanesque churches, which he visited, and for Byzantine mosaics, which he studied in books obtained from the army library. In Boston, he studied with Karl Zerbe, who was instrumental in introducing Kelly to European Expressionism. Among the artists he admired and whose work influenced his early drawings and paintings were Max Beckmann (Zerbe arranged a visit by Beckmann to the Boston Museum School), Picasso and Klee. Kelly was

not at that time concerned with abstraction *per se*. He recognized in Klee and Picasso certain fundamental principles for organizing nature into another actuality that proved useful to his own impulses. In spite of the numerous differences in style and content of the artists he admired, Kelly discovered a way of seizing form directly with minimal use of line. Not surprisingly, he used this to his advantage in his graphic work some time before he could articulate it in his paintings.

Kelly spent the summer of 1947 in Skowhegan, Maine, on a scholarship. *Sluice Gates*, 1947 (Pl. 1), is an early drawing investigating nature and recording the random patterns produced by natural phenomena. A comparison of this brief sketch with several later works, *Brush Strokes Cut into 27 Squares and Arranged by Chance*, 1951 (Pl. 42), *Brush Strokes Cut into 49 Squares and Arranged by Chance*, 1951 (Pl. 41), and *Study for YELLOW WHITE: Yellow Collaged Strips Cut into 16 Squares and Arranged by Chance*, 1951 (Pl. 46), is indicative of the way in which Kelly began to elicit from nature certain forms which he would eventually abstract into line or shape for their own sake, without resorting to naturalistic imagery. As casual and inconclusive as *Sluice Gates* now appears, it represented something more than a quixotic departure from the academicism typical of most student work. The rapid succession of short brusque markings, while failing to articulate the relationship between image and page, was nonetheless admirable in conveying the pattern of water as it flowed over the dam. It was a tentative but succinct example of Kelly's need to articulate perceptual information with art-based concepts. As his point of departure, Kelly's subject suggested an infinite variety of permutations and combinations; yet its ultimate transformation was so varied and far-reaching that it became totally recreated and entirely different from its original state.

Seeing European art, even under conditions as unfavourable as those during World War II, soon made Kelly realize that Boston's expressionist ambience was too stifling. He returned to Europe in October, 1948, on the G.I. Bill of Rights, favoring it over New York for several reasons. Aside from the pleasure of living there, he preferred the anonymity of being a foreigner and the freedom afforded by lack of familiarity with language and customs. Kelly was dissatisfied with his paintings and felt that his physical removal might have a cathartic effect on his work, enabling him to circumvent what he knew and now rejected. Paris based, Kelly saw and admired the work of some of the leading figures of twentieth-century art and visited the studios of Brancusi, Arp and Vantongerloo. But late in 1948 and in the beginning of 1949 he was still intent on representing the appearance of things; objects in nature were more valid to him than abstract art.

Newly arrived in Paris, Kelly felt the need to fall back on his earlier training. Drawings of this time include *Batia*, 1948 (Pl. 3), and *Ninon*, 1949 (Pl. 5), both of which were drawn from life. *Batia* in particular reflects Kokoschka's influence, a carry-over from Kelly's Boston days. The expressive line and the attempt to give the figure something of an inner emotional life were inherently alien

to Kelly's style and were subsequently abandoned. These and other drawings
of the period were characterized by an absence of tonality. No changes,
no erasures, quickly drawn, works like *Ninon* and *Batia* were only intended
as sketches, not meant to be developed into paintings. His subjects were taken
from the life around him—a friend's face or a stubby sneaker, a group of delectable
apples or a graceful plant with leaves, a tree trunk or three intertwined as one.
In his search for the form/pattern in "things," all objects—whether natural or man-
made—were potentially useful to him.

In the spring of 1949 Kelly shifted to abstract forms in his paintings, although
he continued representational drawings which typically presented a single form,
were centered, symmetrical and frontal. Line drawings were simple,
either in ink or pencil, or were quickly brushed in basically monochromatic values.
Color, for the most part, was notably absent and where it was used, served to fill
a shape rather than to define it. The style was direct, sometimes abrupt,
often sketchy. Many of the drawings from this year were useful to him
as notation and only later were they culled and considered as the basis for a
finished work. However representational, these drawings of 1949 indicate the
beginnings of abstraction and the work had, as a result, an experimental quality
as Kelly sought to combine what he recognized in nature with what he knew
and admired in art. The ovoid form and the curve, shapes which assume central
importance in Kelly's later abstract paintings and sculpture, are apparent
in *Self-Portrait*, 1949 (Pl. 4), and *Femme de Chambre*, 1949 (Pl. 8).
In these drawings there is a flattening of form, a de-emphasis on volume and
a compression of the figure into a shallow space, while still savoring the tangible
relationship to actuality. Kelly accomplished this by a sophisticated manipulation
of his subjects. In *Self-Portrait* (Pl. 4), for example, the curve of the jacket and top
of the head combined with the diagonal line running from lower right to left, not
only form part of the figure but relate perceptibly to the edge of the drawing itself.

Kelly's appreciation of the drawings of Picasso and Matisse quickly replaced
his feeling for expressionism, permitting him to elaborate on the relationship
between the figure and the space around it without sacrificing the true
characteristics of the sitter. Even in such a Picasso-like work as the gouache
Self-Portrait, 1949 (Pl. 12), the subject, in this case the artist, is clearly
recognizable. It is obvious that Kelly's fundamental interest is not in giving life
to the sitter, but in restructuring or accommodating the figure to the requirements
of the picture. Kelly relied on the symmetrical "hieratic" placement of the figure,
on the articulation of the form with the ground at the lower edge of the page,
and on the generous use of black—as hair and shirt—to bring the form forward
and to flatten it out. The influence of Matisse, in the synthesis of line and form that
is his trademark, is particularly evident in *Double Self-Portrait*, 1949 (Pl. 6),
in the evenhanded line, the symmetrical placement of the two figures,
and, above all, the shaping of space. Kelly's realization of the space around the
figure enabled him to bring his subject into being as shape. *Head with Beard*,
1949 (Pl. 16), an exception to the generally linear disposition of the early drawings,
hints at Kelly's subsequent concentration on form as mass. Together with

Sneaker, 1949 (Pl. 14), it marks the beginning of Kelly's preoccupation with a single form or "totem". "All my work can be characterized by the number of forms presented or the division of parts." [3] The totemic aspect of the single form provided Kelly with an introduction to the real potential of figure versus ground. The transformation of his subject, from its initial presence to its ultimate reorganization, enabled Kelly to move into total abstraction—although total abstraction as a point of departure was far from immediate, and occurred only after his return to New York in 1954. In the interim, he developed several other possibilities which proved equally fruitful, if not of equal importance to his work.

Although the figure, which dominated Kelly's early work in Paris, can be seen as the foundation for his later single-image paintings and sculpture, the more infrequent plant, fruit and landscape drawings retained a closer proximity to nature, without, as Kelly describes it, resorting to "invented" lines. This continues even in the most recent drawings of 1970. *Apples*, 1949 (Pl. 15), was drawn from many different angles exactly as the subject appeared, without adjustment. The total mass, of nine parts, is supplemented by the space around and between the apples, which performs a more aggressive function than merely serving as background. In this work, the white space becomes a definite shape. *Trunk with Leaves*, 1949 (Pl. 17), is the result of the same method of decoding nature to the extent that its underlying structure is revealed as a viable reality. Concomitant with this ineluctable felt "reality" was the need to convey on paper what Kelly found in nature, an unpredictable but inescapable order. At this time he was not concerned with actuality *per se*, yet he was reluctant to devise a system or organization to impose on nature, committing his art to pure abstraction.

Seaweed, 1949 (Pl. 18), investigates the form of the plant as shape, utilizing positive and negative space. Both the "S" (positive shape) on the left and the "3" (negative shape) on the right become positive forms in the drawing. As shapes, they recur in many later paintings. The conclusiveness with which Kelly could maneuver positive and negative shapes is especially striking when comparing this drawing with *Sluice Gates*. His ability to subvert the form/ground relationship is one that he used to even greater advantage in *Stacked Tables*, 1949 (Pl. 19), where the space between the inverted table legs became positive egg-like shapes delineated by a curve. Although it would be premature to draw conclusions on the basis of this drawing, it is apparent that the curved line enabled Kelly to move one step away from actuality by suggesting the possibility of a relationship between the curve and the rectangle of the paper. The curve and its variations enabled Kelly to confront the edge, accelerating abstraction and leading him ultimately to relief, to shaped canvas, and to sculpture.

Of the landscape drawings, the most unusual is undoubtedly *Jardin des Tuileries*, 1949 (Pl. 2), one of the earliest Parisian drawings. In Kelly's depiction the topiary has assumed curiously surrealistic overtones. Even at its most casual —there is no intimation of background or place—the grouping of forms into

the most vaguely suggested landscape setting would have led Kelly into the trap in which the Surrealists found themselves. In their search for a convincing visualization for the subconscious, the Surrealists chose an abstract imagery which, however unconventional it may have been, devolved into literal objects when placed in a landscape context. The connection with reality, no matter how tenuous, created a vise from which the symbols, so necessary to Surrealism, could never shake loose. The symbolic forms functioned ultimately as surrogates for reality, not as exemplars of the subconscious. Although the Surrealists failed in their attempt to define myth in the language of art, they did demonstrate a profound awareness of the potential of the subconscious, and they succeeded in loosening the stranglehold of a fixed order for art. From the evidence of this work, it is apparent that Kelly found many of their methods profitable, as his later chance collages and automatic drawings indicate. He did, however, reject many of their objectives. Instead of instituting a dialogue between dislocated objects, Kelly opted for the isolation of his forms in order to force from them a convincing dialogue between the demands of nature and those of art. This decision is at least tacitly implied in *Jardin des Tuileries*, where Kelly's lingering obsession with a form and its shadow (exemplified in such later works as *Study for WHITE PLAQUE, BRIDGE ARCH AND REFLECTION*, 1951 [Pl. 55]), is most pronounced, as the shrubs and trees with their shadows are outlined as objects and treated as cutout forms on a ground.

> I like to work from things that I see whether they're man-made or natural or a combination of the two. Once in a while I work directly from something I've seen, like a window, or a fragment of a piece of architecture, or someone's legs; or sometimes the space between things, or just how the shadows of an object would look. The things I'm interested in have always been there. The idea of the shadow of a natural object has existed, like the shadow of the pyramids, or a rock and its shadow; I'm not interested in the texture of the rock, or that it is a rock but in the mass of it, and its shadow. [4]

Kelly's observance of nature-derived forms was further realized in a number of studies for three window paintings which literally depict the subject, yet are not obvious as windows. *Study for WINDOW, MUSEUM OF MODERN ART, PARIS*, 1949 (Pl. 22), is an exact copy of one of the museum windows and expresses Kelly's concern for the rectangle, which he further extended in the painting by developing it into an object. The painting was conceived as a panel because Kelly felt that the architectural situation—the window—called for it. He began to regard this panel and subsequent ones as objects or "architecture." This work was produced in the fall of 1949, one year after his arrival in Paris. When compared with other art (Mondrian has been suggested in this instance), his window paintings were initially the result of his interest in Romanesque architecture. Yet, some vestiges of actuality are retained, because as Kelly states, "I did not want to 'invent' pictures, so my sources were in nature, which to me includes everything seen." [5] Continuing the window paintings, *Awnings, Avenue Matignon*, 1950 (Pl. 25), was derived from a series of awnings which Kelly saw and decided

to duplicate. Each panel is a window of the building facade; each blue awning positioned as Kelly saw it. "The awnings had to be copied as they were seen. There was something magical about finding it just right." [6]

The decision to accept an *a priori* situation led shortly to collage, and to utilizing chance to determine the arrangement of his pictures.

Kelly produced his first collage in 1950 and his being in Paris quite naturally meant the assimilation of the collage tradition, which encompassed such major movements as Cubism, Dada, Surrealism, Futurism, Constructivism, and the mainstream of School of Paris art. This period is marked by the admixture of linear patterns, the introduction of solid, unbroken areas of color, chance composition, and the combination of fragmentation with an all-over intensity to avoid a fixed center of interest. The collages of this period were important in the sense that they also suggested the eventual innovation of the later color panel paintings. Kelly substituted the random order of collage for the unity he had originally sought in nature. "...leaves, grass, cracks in the wall [figs. 2, 4, 5, 10], all the randomness of a million pieces and variations. This way of composing was endless and didn't need 'me'—they made themselves— as it seemed nature worked for me using the laws of chance." [7] *White Fragments*, 1950 (Pl. 24), is an early collage of borders trimmed from photographs. "I liked them because they were different shades of off-white and were the same lengths of varying widths. I decided then to make my own accidents and tore up old drawings and arranged them without composing [*Torn Drawing Rearranged by Chance*, 1950 (Pl. 26), is an example], gluing them just as they fell. I then cut up old discarded drawings [*Cut up Drawing Rearranged by Chance*, 1950 (Pl. 27)]. with razors or scissors." [8] These drawings, arranged in a loose grid composed of squarish segments, constituted a deliberate rearrangement of predetermined parts occasioned entirely without the artist's intervention, other than his initial acts of tearing or cutting and dropping the pieces onto a tabletop or floor. The use of original drawings offered Kelly the opportunity to juxtapose diametrically opposed elements—the cut edge and the brushed mark, the mechanical and the individual—from which the different implications of the impulse and the activity offered a lively contrast not unlike his earlier articulation of curve against rectangle. Using chance to determine arrangement, collage was the means by which he effected his first major shift in direction away from what he had known in the States. It was a shift, not from nature to abstraction, but from the holistic image to the gradual disintegration of the image into minute units which were then reassembled into another totality.

A key pioneer in the development of chance collage was Hans Arp, whose first collages consisted of a series of colored papers in black, orange and blue. In Zurich, in 1915, he made a number of "concrete" collages, resembling the collages of Picasso, Braque, and Gris, in which he used printed papers, fabrics, anything that he could find. Chance played a fundamental role in Arp's philosophy, stemming apparently from his appreciation of Zen Buddhism. The *I Ching*, the Chinese Book of Chances, is based on belief in the significance of the chance aspects of events. The philosophy that Arp devised for his

"papiers déchirés" was based on acceptance of the idea that a work of art could result from tearing up paper and throwing it on the floor, with the disposition of the pieces assuming a sort of occult significance. As crucial to Arp as to Kelly was the idea that these collages were "impersonal." Like Kelly, Arp was fascinated with Byzantine mosaics, which he regarded as essentially collage. Arp's collages fall into several different categories: the "rectangles," arranged according to the laws of chance, made from cut paper; the "papiers déchirés" of unused paper; those made from papers previously drawn on; and, finally, relief collages.

Kelly's experiments with collage were similar but stopped short of the final stage to which Arp brought his collages, since Arp primarily used collage as a point of departure for images that were afterwards deliberately rearranged. While it is true that Kelly applied to his own collages many of the methods that Arp developed, their syntax was entirely different. Kelly was largely indifferent to the materials and textures that fascinated Arp and preferred either his own drawings or commercial color papers which he cut up and rearranged—but only as squares. Where Arp's stylistic evolution progressed from a rectilinear structure to curvilinear biomorphism, from equilibrium and stasis to improvisation, Kelly insisted on greater flexibility, working with both curve and rectangle, refusing to be confined by either a symmetrical or asymmetrical organization. He had no predetermined conditions or systems to which he felt bound, nor did he feel the necessity to invent any. Nevertheless at this time, he seemed to focus on the rectangle with obsessive concentration, after a brief period in which he had been toying with a number of other alternatives.

Although there is a certain resemblance between the collages of Arp and Kelly (in such works as Arp's *Geometrical Collage and Rectangles Arranged According to the Laws of Chance,* of 1916), it was with the work of Sophie Täuber-Arp that Kelly found himself in even greater sympathy. As a pioneer abstractionist, Täuber-Arp had explored the possibilities of using the rectangle in numerous compositions and she often worked these rectangles together to suggest masonry or stonework. The underlying architectural organization of her work must have been of more than casual interest to Kelly, given his own passion for Romanesque churches and architectural detail. Täuber-Arp was concerned with the spatial possibilities of color, its subtle manipulation to suggest planar depth, and its reinforcement by the use of line. By 1916, working in watercolor, she was already dividing up the picture plane into squares and rectangles arranged to vertical and horizontal axes. Arp often credited her with introducing him to many ideas about geometric abstraction some years before he knew of Mondrian's and van Doesburg's paintings. While both Arps used squares and rectangles in intimate juxtaposition, their intention was completely different from Kelly's. The Arps' "planar spatial reality," created by the interplay of colors and planes (they also referred to these works as "Space pictures") was of little interest to Kelly, who preferred to squeeze the space out of his images. When he insisted on the same size square or rectangle, he was able to eliminate any vestigial reference to a form/ground or hierarchical

relationship. Rather than constricting his color, the repetition of identical modules allowed him to free color from subservience to form.

While Kelly was experimenting with chance collage he also did a number of automatic drawings. Ralph Coburn, a friend of Kelly's from Boston Museum days, had arrived in Paris in the summer of 1949. Together they traveled to Brittany, where Kelly remained for the entire summer. During the summer, and afterwards when Coburn went to the south of France, they corresponded, exchanging ideas about their work. In the dialogue that ensued, many of the concepts essential to Kelly's later work began to form. During this time they discussed Dada and Surrealism at length and actually collaborated on several drawings. Kelly never wanted to convert automatism into a system. He wanted to use it as a means to rid himself of preconceptions about art. Arp had already carried automatism to the same lengths as chance collage, using the automatic-pencil drawings as the first stage for finished works, inking the contours, filling in certain shapes, even eliminating some. In Kelly's automatic drawings, there is no alteration, nor were they intended as the basis for other, more finished works. The drawings are as immediate and spontaneous as those produced by Miró and Masson in the later 1920s. *Automatic Drawing: Coat Hangers*, 1950 (Pl. 28), like *Automatic Drawing: Pine Branches*, 1950 (Pl. 30, also fig. 3), was the result of looking at the subject, not at the paper. *Automatic Drawing: Shelled Bunker*, 1950 (Pl. 31), was drawn from the bent metal supports holding together the concrete blocks of a bombed German World War II beach fortification. Like the others, this drawing is subject not to the page, but to the random order of hundreds of branch-like strips of metal (fig. 1).

The random order that Kelly saw in "nature" is best exemplified by photographs that he has taken intermittently since the late forties. Starting in 1949, these early photos were so small and poorly developed that they were discarded, and he has only recently reprinted and enlarged some of them. His subjects cover a wide range of material, from tree tops to cows and stair railings, from architectural details to the double line on a highway—anything, in short, that captured his interest either because it reminded him of his own work or because it might be useful in some as yet unknown fashion. While these photographs have been used as specific source material, they are chiefly of interest because they document the artist's way of seeing. Both Kelly's photographs and indeed his entire body of work to date demonstrate a palpable organic quality. Even the most abstract works, his severely geometric panels, stem from a humanism or naturalism that is a consequence of his evident need for reality as his point of departure. His work derives from his environment—a barn door, a plant, or a shadow between the legs of a chair—and is in turn reflected not by duplication of his subject but by scale (few of his works exceed human scale), by contours that are often biomorphic, and by color that is usually so intensely hedonistic that seeing it we think of human passion rather than abstract fact.

Kelly taught briefly in 1950 at the American School in Paris, where he gave his pupils projects in spilling and blowing paint, and decided to emulate their

spontaneity and abandon. Noticing the thinning leaves in the fragmented view from the window of a bus, Kelly realized *Autumn Trees*, 1950 (Pl. 34), by dropping ink from a brush onto the top of a page. In *Grass*, 1950 (Pl. 33), the thinned ink was allowed to run down the page and the path guided by blowing on the liquid. He also picked up the bits of paper left by this students and in *Children's Leftovers Arranged by Chance*, 1950 (Pl. 40), by letting the fragments fall at random and then gluing them in place on the page, he indicated that anything and everything could be appropriated. The same method was employed for the design of *Colors on Black*, 1951 (Pl. 39), his exhibition invitation for the Galerie Arnaud, which was never used. Of prehaps more interest than the procedure are the shapes seen here, as they prefigure the images of his post-Paris work.

The reflections cast by the play of sunlight on the Seine, the shadows of a railing on a flight of stairs and the configuration of pipes on an outside wall were the result of "finding in nature what I had been doing in collage." [9] In *Study for LA COMBE III. Shadows on a Staircase*, 1950 (Pl. 35, fig. 11), the steps break up the straight lines of the railing into a fragmented version of the original. Kelly made three different versions, at 10 a.m., noon, and 2 p.m., recording the changing shadows. *La Combe I*, 1950, one of three paintings executed from these studies, is folded like a screen to duplicate the formation of the stairs, a transformation of natural phenomena into a pure statement of black and white. This hinged, nine-panel painting and its larger counterpart, *La Combe II*, one long horizontal unit, were an important extension of Kelly's discoveries in collage. They are the first concrete evidence of his interest in abstraction and formalization so that there is virtually no indication of the original source in nature. By hinging the panels together, Kelly maintains a reference not to the subject, but to an approximation of the play of light and shadows rippling across the surface of the steps, through a process of visual "feedback," which seems to contradict the fact of the painting. This insistent image, which occurs despite the separate panels, was the logical outcome in painting of his collage experiments, where he found a means to loosen the dominance of form over ground.

Moving from holistic shape and fragmentation to extend the innumerable variations that developed from chance collage and automatic drawing, Kelly made another breakthrough, equal in importance to the La Combe series. Several chance collages of 1951 have a common profile: they feature an all-over pattern in which no one portion dominates—they are especially resistant to a focal point; all of them use a square or a grid system as the organizing factor. The open, predominantly linear configuration of *Brush Strokes Cut into 49 Squares and Arranged by Chance*, 1951 (Pl. 41), gives way to the thick cluster of brush strokes in *Brush Strokes Cut into 27 Squares and Arranged by Chance*, 1951 (Pl. 42), and *Study for CITÉ: Brush Strokes Cut into 20 Squares and Arranged by Chance*, 1951 (Pl. 47). The deliberate placement of forms demarks one square from another in *Study for GREEN WHITE: Green Collaged Strips Cut into 20 Squares and Arranged by Chance*, 1951 (Pl. 44), and forms extend across a square in *Study for MOBY DICK, Red Pieces Arranged on a Grid*, 1951 (Pl. 45). The concerted opposition of horizontal and vertical patterns

within the grid is seen in *Study for YELLOW WHITE: Yellow Collaged Strips Cut into 16 Squares and Arranged by Chance*, 1951 (Pl. 46), and *Color Strips Arranged by Chance*, 1951 (Pl. 48), a collage made with left-over color strips, shows vertical colors placed at random. In each instance, the grid system is prominent, and its boundaries are exploited by moving at variance to it. By juxtaposing squares, however, Kelly retains the separate identity of each unit, tantamount to a contradiction of the grid system. In other words, he is working with two fundamentally different elements: the separation of parts—manifested by his continuing use of fragmentation—and the overall intensity of the pattern, which is especially successful in *Study for CITÉ: Brushstrokes Cut into 20 Squares and Arranged by Chance* (Pl. 47).

In preparation at the same time as his chance collages, Kelly's project for a book, *Line, Form and Color*, 1951, was an application for a Guggenheim Foundation Grant. As an introduction to the project he wrote:

> This book will be an alphabet of pictorial elements without text, which shall aim at establishing a larger scale of painting, a closer contact between the artist and the wall, and a new spirit of art accompanying contemporary architecture. [10]

This group of about 50 ink drawings and collages was not only a summation of his earlier involvement with form, line and color, but was a catalyst for the later work of the fifties and the sixties. Using the page and the edges of the paper as the constituent feature of the work, the book began with horizontal and vertical lines, the grid, stripes (Pl. 49), diagonal (Pl. 50), and curve (Pl. 51). Form was introduced with a page of white and a page of black, followed with horizontal and vertical bands (Pls. 52-53), the square, the triangle and the circle. Color was then presented with a page each of red, yellow, and blue and combined with line and form, as in *Green Forms* (Pl. 54).

The project, concerned with solutions to drastically reduced elements, did produce a renewed, if temporary, interest in the curve. Kelly credits his further development of the curve in this series with later projections of the curved form into cutouts, relief, and ultimately into free-standing sculpture. The curve provided him with a form that was sufficiently advanced, independent of the rectangle, and capable of being manipulated both as shape and as dimension. *Study for WHITE PLAQUE, BRIDGE ARCH AND REFLECTION*, 1951 (Pl. 55), was originally planned as an all-black construction. The arch in shadow and its reflection in the water appeared as black in contrast to the light-catching surfaces of the bridge and water, but Kelly decided to leave the final version in its white underpainting stage. Like the *Study for WINDOW, MUSEUM OF MODERN ART, PARIS* (Pl. 22), and *Awnings, Avenue Matignon* (Pl. 25), this wood cutout is a continuation of Kelly's alteration of natural phenomena. Although Kelly is faithful to the original, equating both the object and its cast shadow, the alterations are startling. Not only has the color been drastically changed, to catch the light rather than diminish it, but the adjustments of contour and the use

of the cutout make its transformation all the more complete. The early wood cutouts led directly into relief. The reliefs were then seen as cutouts on a ground. The third and final stage was the elimination of the ground and the introduction of freestanding sculpture. Since the early fifties Kelly has worked in reliefs, which, like his sculptures, are few in number but of ongoing interest to the artist.

Kelly worked with chance collage into 1952, experimenting first with hundreds of fragments, then reducing the units of a collage to a few elements. As he refined the number of units in each collage, his emphasis on color became more pronounced. The use of color squares represented a major commitment on his part to mass and color. Their drastic simplification to a few components enabled Kelly to recognize their significance: as separate panels they could carry his color while retaining their integrity as shape. His extensive use of collage during 1951-52 enabled him to quickly test some of his theories. Whatever collage meant initially to Kelly, by way of association or allusion, it became simply a convenience, useful in mapping out new directions. His predilection for a rectilinear grid notwithstanding—in this sense a response to the Cubist grid—he was able to wrest from it a surprising number of variations, many of them used as studies for paintings; others put away for future reference. Kelly tested color arrangement and variations in black and white and experimented with horizontal stripe compositions which were never made into paintings (Pls. 69, 70). This omission is all the more unfortunate in view of subsequent developments by other painters during the sixties. Although Kelly could work out the general proportions and spatial arrangements of his forms with collage, the colors themselves were rather rudimentary. Since Kelly pasted up whatever colored papers he could find—the paper varies considerably from his Paris period to the later work done in the States—it became necessary to determine the appropriateness of his color and to make the final adjustments on the canvas. He discovered that scale was a vital factor in determining the outcome of his color relationships and that the same colors situated next to one another in a small sketch or collage changed dramatically when enlarged. Since he worked with color intuitively, it was impossible to foresee the outcome of a painting solely in a collage.

In works like *Study for SEINE, Chance Diagram of Light Reflected on Water*, 1951 (Pl. 56), Kelly's dependence on natural phenomena is once more evident, forming the basis for his pattern of light and dark. The play of light reflections was reduced to a grid system, which he then filled by progressing from the sides to the center. Position was determined entirely by chance, as he pulled numbered pieces of paper out of a hat to avoid making arrangements by any other means. Instead of coaxing the fragmented play of light on water into a variation on pointillist methodology, Kelly decided to impose his own more arbitrary system, which became the basis for his color collages. This procedure dictated the outcome of collages like *Spectrum Colors Arranged by Chance #2*, 1952 (Pl. 58), and *Spectrum Colors Arranged by Chance #5*, 1952 (Pl. 59).

Study for SIXTY-FOUR PANELS: COLORS FOR A LARGE WALL, 1951 (Pl. 60), and *Study for SANARY*, 1951 (Pl. 61), have prompted comparisons

to Mondrian's *Composition: Checkerboard, Bright Colors* and *Composition: Checkerboard, Dark Colors*, both of 1919, but the comparison does not really apply. In addition to the fact that Kelly had never seen these paintings, Mondrian's checkerboards have an amazing regularity, unusual for an artist who was obsessed with balanced asymmetry. The essential structure of Mondrian's work, however, is the reticulation of vertical and horizontal black lines with which he endeavored to prevent any inordinate fluctuation of color in space. The asymmetry in a Mondrian, then, is largely predetermined by this system —or at least by an armature supported by the placement of his colors. Kelly's collages, on the other hand, and the paintings after the collages, while seemingly regular, have considerable disunity which stems from the way in which the colors are grouped. For Kelly, the asymmetrical distribution of colors was not calculated and therefore cannot be construed as a debt to Mondrian. Indeed, in this respect, a much closer alliance in both procedure and outcome would seem to exist with such works as the Arps' *Duo Collage*, 1918.

Kelly's need to give color its own concrete "reality" was largely his own invention. It prevented the utilization of a system like Mondrian's, whose rectilinear subdivision of space can be viewed as an extension of Cubism. For Mondrian, the Cubist armature was essential, even though he relinquished the black grid in a late work like *Broadway Boogie-Woogie*, 1944. His color was structured so as to retain at least the implicit vestiges of such an organization. Mondrian moved from a complex, fragmented surface to a simplified image and finally returned to his former method. Kelly, on the other hand, has indicated a preference for squeezing the space out of his work by using two devices: juxtaposition of solid areas of color without benefit of either line or white spaces —which in Mondrian seems to function as the equivalent of "passage"— and the emphasis of the concrete authority of color by giving it dominion over its own space.

For pioneer abstractionists like Mondrian and Kandinsky, the role of color was envisioned as purely symbolic. This mystical belief, founded in Theosophy, gave a particular meaning to each color, thus creating a new "reality." Kelly, however, perceived the "reality" of color in his use of the rectangle, although this has by no means been his only priority. The regularity of his forms, rather than constricting his color, enabled him to free color from subservience to form. For Arp, the new "reality", at first expressed by geometric means, eventually came to be allied with the human form, from which he derived a number of organic shapes that he applied to collage, painting, relief and sculpture, formulating a "concrete" art. The compression of space into a single plane, a development of Cubism, led to relief in Arp's case and to both relief and the use of single color panels in Kelly's work. Kelly progressed from the representation of subjects in nature to arrangements of color by chance. This eventually extended to a deliberate selection of colors, and then finally to the gradual reduction of form and enlargement of scale, completely transcending any early influences.

Kelly has been one of the few colorists capable of severely limiting his colors —successfully combining one color with black or white—while simultaneously expanding their possibilities. The only other artist who comes to mind in this respect is Barnett Newman, but here again the differences are more compelling than any similarity. Using a drastically reduced color scheme, Newman's interest in activating the field and endowing it with a vast spatial expanse necessitated unequal areas of color, and reliance on a stripe or narrow ribbon of color. For this reason, the dragged brush or fudged edge was vital to charge the surface. Kelly wanted something quite different to occur. He was not interested in the limitless extension or the field *per se*, but rather in aligning colors in modular units, which he could extend, as in his later spectrum paintings (Pl. 137). By subduing form and eliminating background in the panel paintings, he could allow color to suggest mass and to be both form and ground. And, as he has remarked, the Abstract Expressionists still thought of the canvas as a field of action; Kelly wanted his work to function as an object which related to the wall, to the room, to architecture.

In the twin concern for mass and color, it is plausible to read a relationship between Kelly's work and that of Matisse, especially the late Matisse cutouts. While one could attribute to Matisse a certain influence in terms of line and the shapes that resulted from it (there is certainly a predilection in Kelly for the type of hooked line that Matisse favored), Kelly's innovations in color owe little to him. Unlike Matisse, Kelly created a color in which representation no longer served any overt role, and established a color which no longer functioned to define form—it became form. Kelly liberated color through chance, and his color alignment, or grouping of colors often in pairs but occasionally in larger numbers, is non-hierarchial and serves no function other than its self-expression. In this respect, he is, as he explained it, primarily concerned with "naming" colors.

At the same time that Kelly was developing his color arrangements, he was concerned, to a lesser extent, with exploring the potential of black and white. In a work like *White and Black*, 1952 (Pl. 64), based on an apartment-house façade, he deliberately attempted to offset the black ground by the very tactile and explicit superimposition of the white rectangles. The black network acting as the field conveys the totality of the image, a deliberate if subtle effort by the artist to indicate the different roles to which he has consigned them. He reinforced this structure by positioning the white rectangles at the interstices of the black grid. Their position, however, allows them to activate the black field. That Kelly regarded black and white in much the same way he regarded other colors is indicated by the collage *Study for TWENTY-FIVE PANELS: TWO YELLOWS*, 1952 (Pl. 63). Less emphatic in juxtaposition, the subtle manipulation of two values of the same color nonetheless conveys much the same relationship as *White and Black*.

In 1952-53, before he returned to the United States, Kelly produced a number of key works. *Study for SEVEN PANELS: RED, YELLOW, BLUE, WHITE*

AND BLACK WITH WHITE BORDER, 1952 (Pl. 65), prefigures later
developments. Seven panels, separated by a border of white as if to emphasize
their singular identity, are related to each other by virtue of their common
container, the rectangle, and the apparent relationship between the colors.
Two of the panels are white, both to serve as separation between the colors
and to act as leverage on them. This collage is in fact related to Mondrian in its use
of primary colors and white. The hues, however, are adjusted so as to hold them
to the same plane. In working out his ideas about color, Kelly decided
to experiment with different formulas. The first was the literal separation of colors
in rectangular formats (Pl. 65), (actually preceded by *Eight Color Pairs*,
1951 [Pl. 62]), which led to a more overt pairing of colors in *Study for
ELEVEN PANELS: KITE II*, 1952 (Pl. 66), where four colors—blue, yellow, red
and green—were each stacked over black and interspersed with a panel of white.
Then, horizontal bands of color were used in *Boats in Sanary Harbor*, 1952
(Pl. 68), *Study for Six Color Panels*, 1952 (Pl. 69), *Study for Four Color Panels*,
1952 (Pl. 70), and *Study for Three Color Panels*, 1953 (Pl. 80).
Other formulas were: the notching of colors, in *Red White and Blue*, 1952 (Pl. 73);
the array of colors against a white ground in *Nine Colors on White*, 1953
(Pl. 75); its reversal in *Nine Colors on Black*, 1954 (Pl. 76). *Study for Five Color
Panels for a White Wall*, 1952 (Pl. 74), however, seems the most retardataire
in its concern with the spatial interplay of color. Although Kelly was concerned
with the relationship of the panels to the wall, the end result was the creation
of a white field and shifting planes of color in a manner reminiscent of pioneer
geometric abstraction. The most radical of the collages simply butt color rectangle
against color rectangle (Pls. 68, 79), and *Study for Four Color Panels*, 1953 (Pl. 78).
A work like *Study for Four Color Panels*, 1953 (Pl. 77), like the *Study for Five
Color Panels for a White Wall*, 1952 (Pl. 74), retains vestiges of constructivism,
but for the most part Kelly had moved away from those ideas by this time.

The collages that Kelly produced after his return to New York in July, 1954
made use of the fragmented forms of his earlier work. The forms are drastically
simplified, enlarged and confined to either single, double or triple forms,
straight-edged or irregular in shape. Form takes precedence together with the
reintroduction of the curve, replacing the exclusive concentration on color
in the work that directly preceded his departure from Paris. Concurrently there is a
renewed interest in black and white. Kelly has stated that the black and
white paintings were partly a reaction to his return to the States; he had followed
a similar pattern in October 1948 upon his arrival in Paris, where he began
with a group of white paintings followed by black and white work, followed in turn
by the introduction of color, or it may simply have been a response
to New York.

Gauloise Blue with Red Curve, 1954 (Pl. 83), was the first New York collage,
a postcard that he sent his friend Ralph Coburn as a memento of his stay in Paris.
The Gauloise blue was removed from the cigarette pack; the red removed
from a magazine; together with white they formed the French tricolors.
Many of the sketches he worked out at this time were curvilinear in shape

and were executed as paintings at a much later date. A painting like
Blue Red Green, 1962-63, now in the Metropolitan Museum of Art, is based
on sketches of 1954-55 (see Pl. 89). If the mid-fifties appears to be another period
of assimilation and reassessment, then the re-introduction of the curve can be
seen as a cautious advance. Some of the curvilinear works may appear biomorphic;
however, *White Curve on White*, 1955 (Pl. 85), was traced from a wire
that had fallen across a white page. *Study for a White and Black Painting*,
1955 (Pl. 91), was concurrently a development somewhat related to his earlier
Guggenheim project. While re-working some of these ideas into paintings,
Kelly began to think in terms of sculpture. The postcards of 1957 (Pls. 101, 102, 103)
prefigure his interest in large-scale sculpture, which he could not begin to realize
until 1959, and then only on a much smaller scale than he originally envisioned.

From 1956 to the present, most of the drawings and collages have been
specifically intended as studies for paintings. During this time Kelly has produced
a considerable number of plant drawings as well as a few abstract or
figurative drawings. In many ways a reconsideration of his first drawings of the
1940s, they are an extension of his concern for marking or shaping space with line
alone. The drawings are quite explicit when they refer to subjects in nature,
yet Kelly's fascination is still for the form, and the space around the form.
Using the minimum of strokes—several of them are so identified—Kelly evokes
the realization of a plant that in no way interferes with the two-dimensional
surface of the paper. Brisk and sure of stroke, they have none of the tentative
hesitation of those first drawings. The space is organized to hold the page
with a minimum of effort and the works seem effortless in their achievement.

Kelly's interest in shape and in the spaces between forms which figure so
prominently in his early Parisian paintings and drawings reappears in his work
in New York. The curve that dominated his paintings of the late fifties is significant
in his drawings, as is his predilection for a single image. Kelly has indicated
that his interest in plant drawings led him into sculpture by manipulating
fully dimensional plant forms into a compatible relationship with a flat surface,
and then reversing this process. Drawing like *Three Leaves*, 1965 (Pl. 149),
for example, has a totality of form that very much resembles the type of cutout that
led directly into sculpture. The form/ground relationship, a vital aspect
of Kelly's painting, was coordinated to a large extent by the relationship
between colors. Since this solution was not available to the drawings, Kelly turned
to other aspects of positive/negative space relationships. As most of the plant
drawings reveal, Kelly felt compelled to locate the center of the page
either by the placement of his forms, as in *Four Oranges*, 1966 (Pl. 152), or by
bisecting the page with a plant stem. A careful examination of these plant
drawings reveals that Kelly seized upon the opportunity to use natural forms
to explore the formal possibilities of his subjects and the page. In one example,
Orange Leaves, 1969 (Pl. 159), four plant leaves set up four spaces in a pinwheel
effect, which, while not rigid in the breakdown of space, reveal a calculated
interaction with the center, sides and corners of the page. Rather than organizing
these forms in a rigid geometric fashion, Kelly gracefully allows each plant

to retain its own characteristics, without denying its potential as abstract form. The cluster of jagged leaves in *Chrysanthemum*, 1967 (Pl. 157) serves as a foil for the simpler and softer shape of the flower. In another drawing, *Wild Grape Leaves*, 1961 (Pl. 146), the foliage proliferates with such lavishness that it assumes an almost organic quality. To maintain the continuity between image and page, Kelly uses an evenhanded stroke with few gratuitous flourishes. This economy of line serves to define shape without making the area around it subservient. The space retains an integrity which it could not possess if he were freer with line. His line is uninflected, and controlled, which allows expression of form but is not expressive of itself, and in this respect, Kelly's drawings are closer to Lichtenstein's than to the emotive content of Oldenburg's. The recent drawings are a definitive indication of the distance between the works of the late fifties and sixties and the earlier Boston/Paris drawings.

The curvilinear or biomorphic form of his drawings characterized his paintings of the late fifties and early sixties. The paintings feature two-color arrangements with one form as subject, slightly in advance of the secondary form, or ground. These forms establish the crucial one-to-one relationship within the picture plane. Kelly experimented with two form/ground relationships. In works like *White Form*, 1956 (Pl. 96), *Study for SUMAC*, 1958 (Pl. 106), *Blue and White on Black*, 1959 (Pl. 114), and *White on Green*, 1961 (Pl. 124), the complete shape, closed in contour, was restrained by its placement within the framing rectangle and was suppressed by the resulting negative space. In works like *Study for a Relief*, 1958 (Pl. 107), and *Whites on Black*, 1958 (Pl. 108), however, the ground has been diminished so that the open-ended form cuts through to the edge and coincides with the edge of the picture support. In this way, Kelly could situate the form so that it subdued the surrounding space. The activation of form against ground and the return to the curve predominant in the late fifties, is in contrast to some of the work of the earlier Paris period, where ground was eliminated. Therefore in these earlier works, form/ground relationships had not been an issue. The picture plane was unified by the grid system, which held the juxtaposed color squares or bands, as in *Color Strips Arranged by Chance*, 1951 (Pl. 48), or *Study for SANARY*, 1951 (Pl. 61). In the later works, however, the ground functioned as a complement to the form, without which it would cease to exist. The Yin-Yang relationship is an absolute necessity, for the image would not otherwise be complete. This concern with form/ground relationships which coincided with Kelly's return to New York, might suggest a need to find a psychological "ground" in his new environment, in contrast to his previously expressed desire for anonymity and freedom while working in Paris. Kelly does not, however, view his work as one of linear development. It can best be appreciated as an ongoing, overlapping process that enables him to keep returning to his paintings, and especially his drawings and collages, in search of material which he had not previously considered but which remains potentially useful.

As an alternative to the curve, Kelly returned to the more neutral rectangle. In his work of the 1960s he used both a regular format, as in *Blue and Red*,

1966 (Pl. 135), and in *Study for TWO PANELS: BLUE WITH SMALL RED*, 1969 (Pl. 139); spectrum arrangements and a considerable variation in his use of color, as in *Study for THIRTEEN PANELS: SPECTRUM VI*, 1968 (Pl. 137). In this work, Kelly reinforced the rectangle by two methods: keeping his colors so close in value that they could not shift optically, and using separate but contiguous canvases with light-dark color relationships. The slight thickness of the stretcher bars stressed the object quality of the painting. A comparison of *Blue and Red*, 1966 (Pl. 135), with *Study for TWO PANELS: BLACK GREEN*, 1970 (Pl. 140), illustrates two of the many solutions which he discovered while working with the rectangle. In the former, the equal intensity of red and blue manifests a static equilibrium perfectly in keeping with the equal proportions of the two panels. The more dynamic balance of the second study is in contrast, as the pressure of the black assumes a relatively significant role although it occupies the smallest portion of the image. This work differs from *Blue and Red* in the tension that permits the less aggressive green to emerge as a challenge to the dominant black. Kelly has employed balanced asymmetry by enlarging and expanding images and reducing their numbers, and the work is psychologically unnerving precisely because both colors exist on the same plane, each housed in a separate area but sharing a common boundary; without an implication of a form/ground relationship. Through his awareness of Mondrian's ability to manipulate color relationships Kelly has successfully juxtaposed two decidedly unequal forms, in a work like *Study for TWO PANELS: BLUE WITH SMALL RED*, 1969 (Pl. 139), while forcing the forms to equalize each other in the picture plane through color intensity. Although Kelly allows a considerable leeway between the collages and the paintings, the position of the colors, as in the above example, is usually conclusive from the outset. The appropriate hue, value and intensity of the blue in relationship to the red form was worked out after some trial and error, to force the issue of balance and the single plane. Within the larger framework of the painting, Kelly has pushed his color to an even greater expansiveness and his forms to their optimum mobility.

Having explored the curve and rectangle, Kelly turned to other shapes, among them the parallelogram or rhomboid, which figured prominently in a group of paintings executed in 1968. As a shaped form, *Study for UNESCO Mural, TWO PANELS: GREEN BLUE*, 1969 (Pl. 138), retains both the ambiguity of the rectangle and the expression of the curve. By the nature of its configuration it offers a closed complete form and implies direction by the energy drawn to its corners. It allows Kelly to return to the draughtsmanship that was so prevalent in the use of the curve and in the attenuation of its proportions, without drawing unnecessary attention to the edges. Kelly seems to relish the obviousness of the triangular form, but subverts its geometry by converting it through juxtaposition into another configuration. Like his entire vocabulary of forms derived from nature, *Sneaker*, 1949 (Pl. 14), is fundamentally a triangle, with the lace dividing the form into two parts. The triangular painting of 1968, *Yellow Black*, is divided in exactly the same way, an indication of Kelly's ongoing interest in breaking down form into separate but interdependent component units.

Perhaps the most striking feature of the use of the triangle is the dialectical tension that is established between linear perspective and the solid color mass. With this new emphasis, form assumes the additional role of direction while color maintains its function as physical substance, static and frontal. This marks a return ot the earlier monolithic canvases that featured interior curved forms without a loss of exterior consistency. The inital emphasis on a linear perspective which forces the eye to follow a converging diagonal is ultimately countermanded by the evenly balanced colors which force the exterior shape into prominence. One of Kelly's latest works, *Study for GREEN BLUE*, 1970 (Pl. 141), is similar in intention, both directional and quiescent, although he has chosen to return to using the curve. Together with this group of works, Kelly is currently at work on a series that employs the rectangle. Both bodies of work testify to his continuing delight in finding new solutions to seemingly limited means. At this juncture it is possible to foresee a greater and continually provocative series of images for the future.

Diane Waldman

1, 2, 3, 4. "Interview with Ellsworth Kelly", by Henry Geldzahler, catalogue essay. *Paintings, Sculpture and Drawings by Ellsworth Kelly*, Washington, Gallery of Modern Art, December 11, 1963–January 26, 1964; Institute of Contemporary Art, Boston, February 1–March 8, 1964.
5, 6, 7, 8, 9. In conversation with the author.
10. Kelly, Ellsworth. *Line, Form and Color*, 1951. Unpublished book prepared as project for a Guggenheim Grant.

Figure 1. Shelled bunker, Meschers, France, 1950

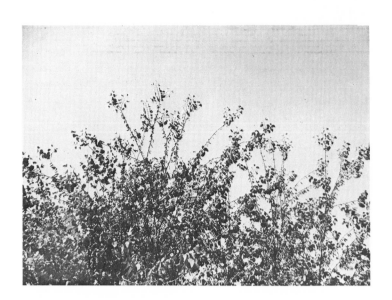

Figure 2. Acacia leaf patterns, Meschers, France, 1950

Figure 3. Pine branch and shadow, Meschers, France, 1950

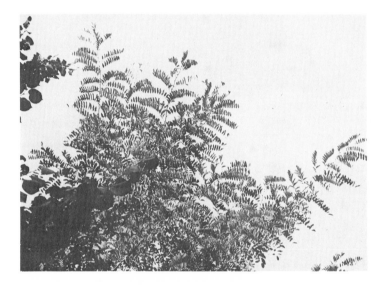

Figure 4. Leaf and branch patterns, France, 1950

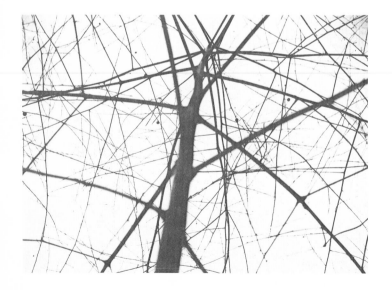

Figure 5. Asparagus, Meschers, France, 1950

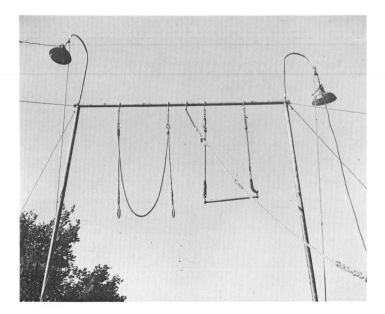

Figure 6. Trapeze swings, Meschers, France, 1950

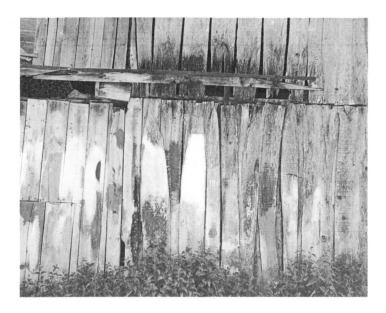

Figure 7. Barn wall, Meschers, France, 1950

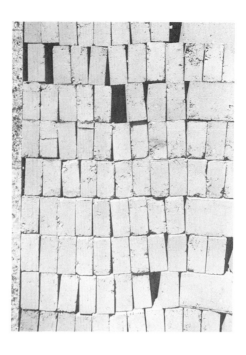

Figure 8. Bricks, Meschers, France, 1950

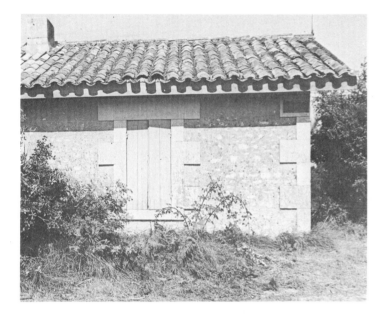

Figure 9. Farm house with tile shadows, Meschers, France, 1950

Figure 10. Courtyard wall with cracks, Paris, 1949

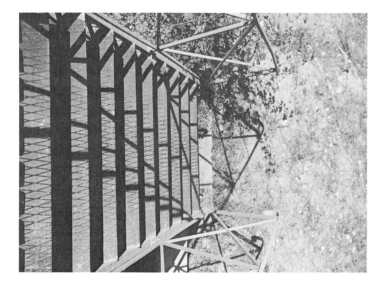

Figure 11. Shadows on a staircase, Meschers, France, 1950

Figure 12. Shadows from balcony, Meschers, France, 1950

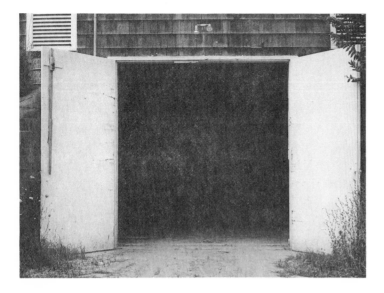

Figure 13. Potato barn door, Long Island, 1968

Figure 14. Potato barn door, Long Island, 1968

Figure 15. Side of a barn, Long Island, 1968

Figure 16. Barn windows, Long Island, 1968

Figure 17. Barn windows, Long Island, 1968

Figure 18. Barn door, Long Island, 1968

Figure 19. Crosswalk, New York City, 1970

Figure 20. Sidewalk, New York City, 1970

Figure 21. Board and shadow, Long Island, 1968

Figure 22. Curve seen from a highway, New York State, 1970

Drawings and Collages 1947-1970

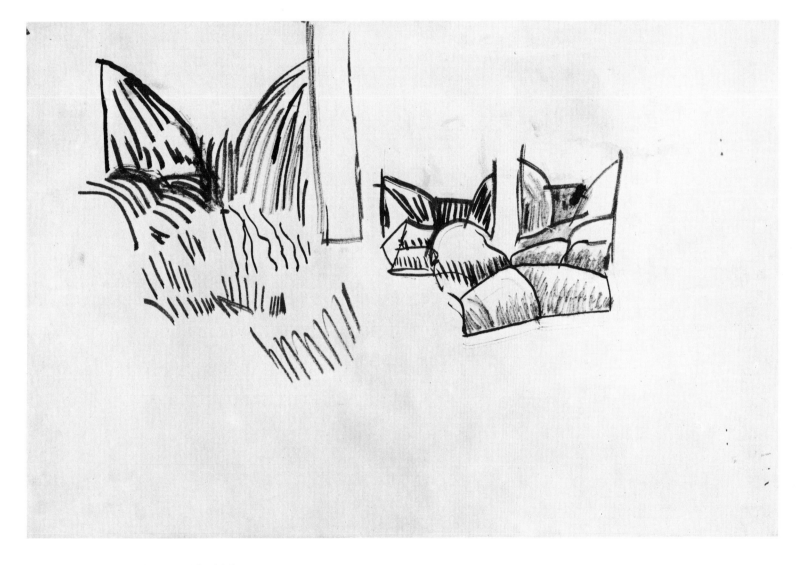

1. *Sluice gates,* 1947. Ink, 12×18 in.

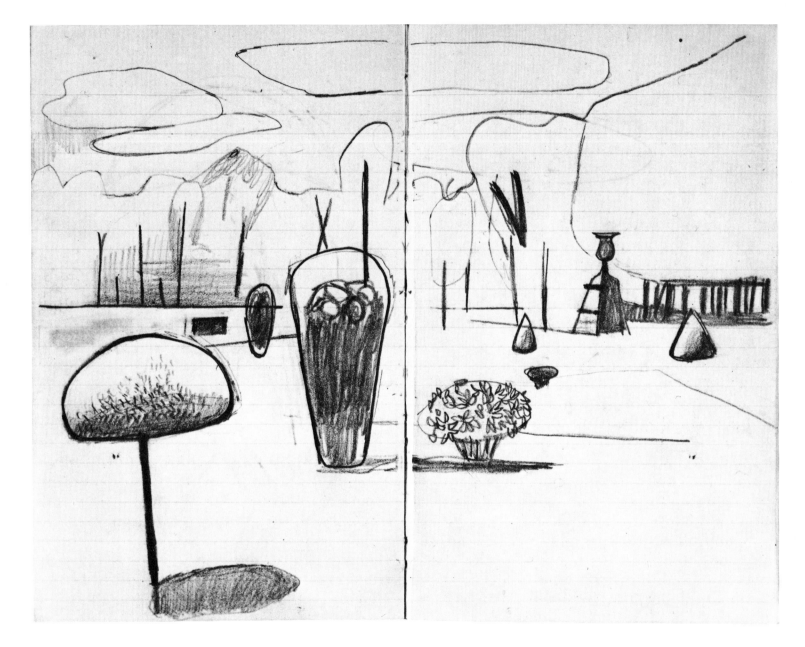

2. *Jardin des Tuileries,* 1949. Pencil, 8¾ × 10⅛ in.

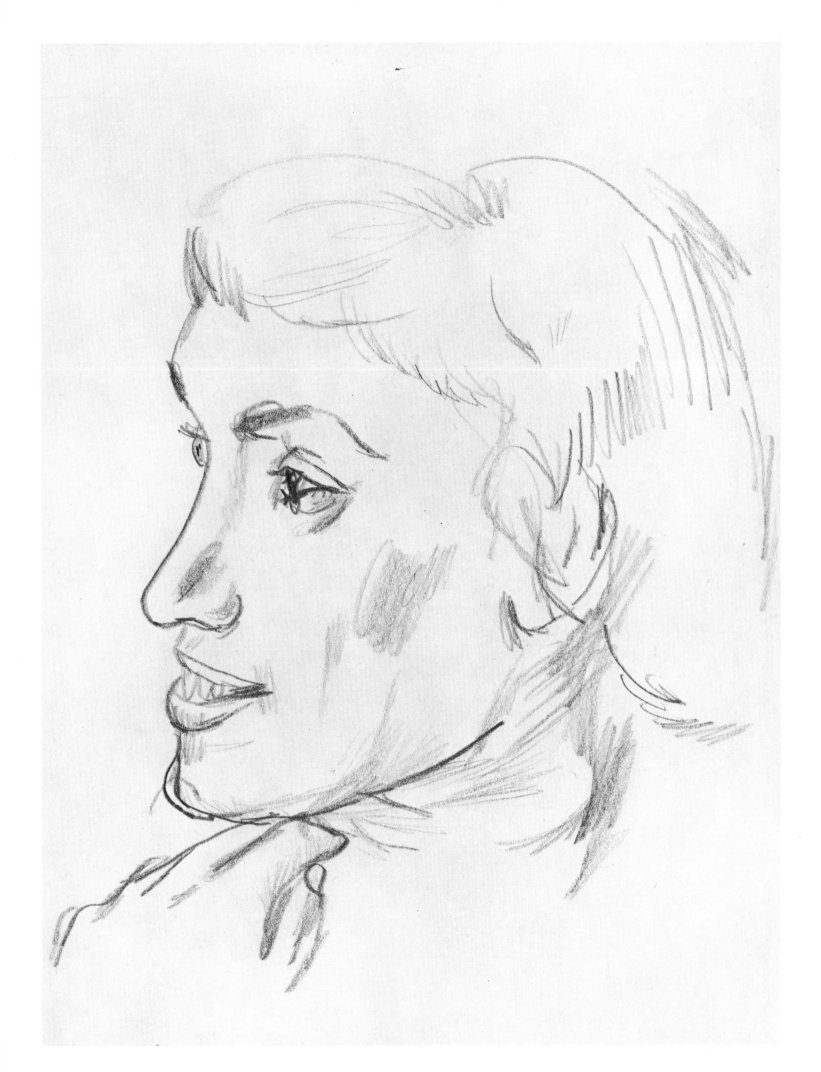

3. *Batia,* 1948. Pencil, 10½ × 8 in.

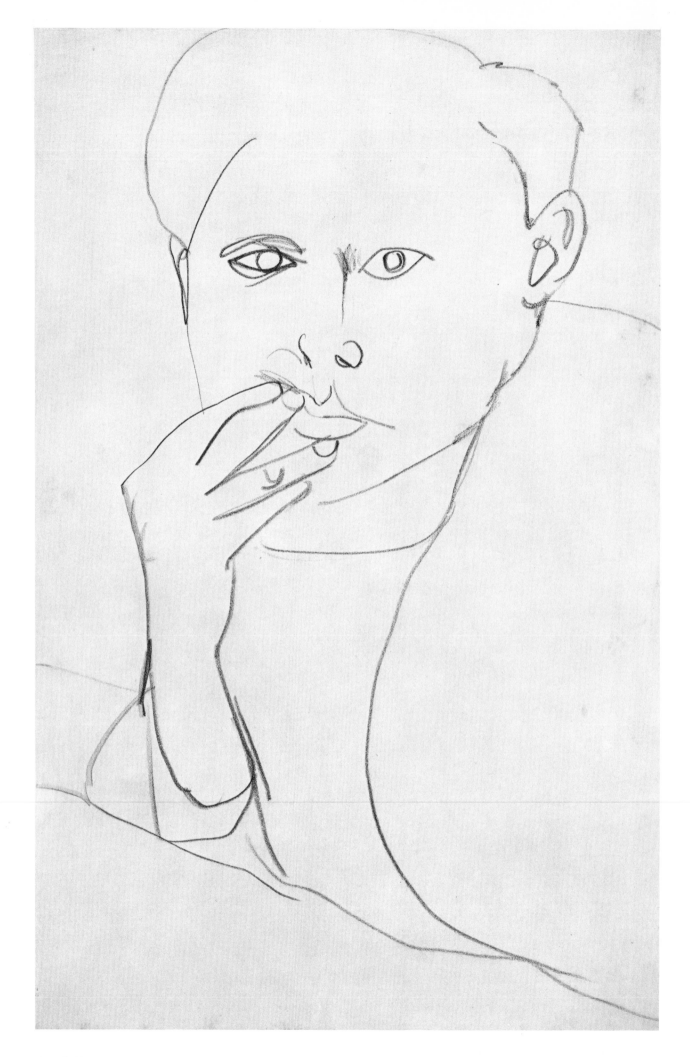

4. *Self-portrait,* 1949. Pencil, 18⅞ × 12¼ in.

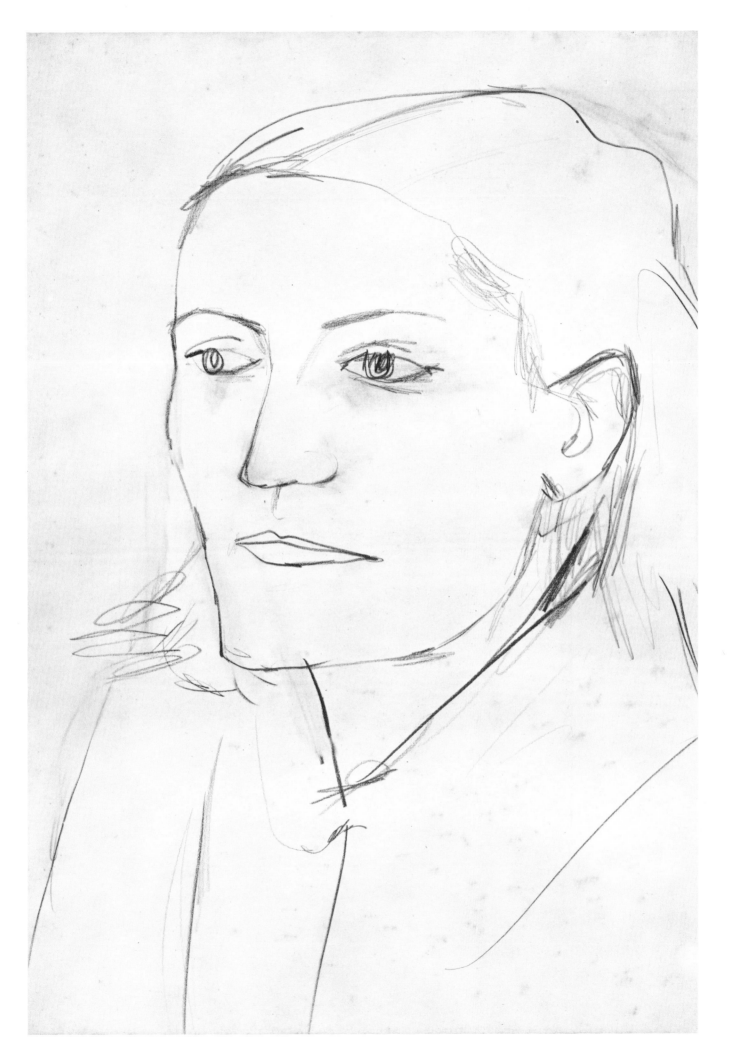

5. *Ninon,* 1949. Pencil, 17¾ × 12¼ in.

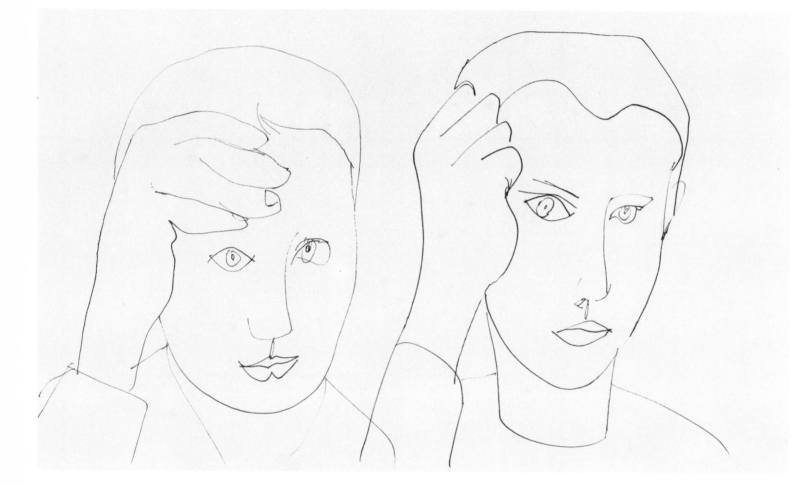

6. *Double self-portrait,* 1949. Ink, 10½ × 17⅛ in.

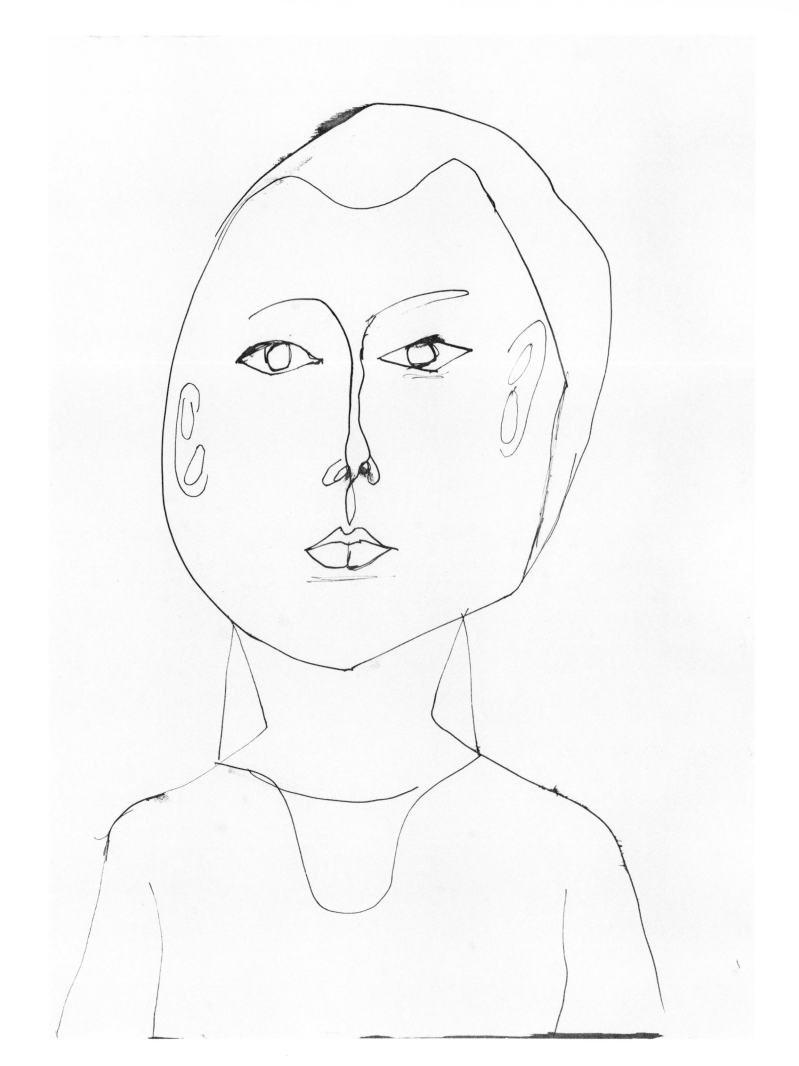

7. *Self-portrait,* 1949. Ink. 16½ × 12⅛ in.

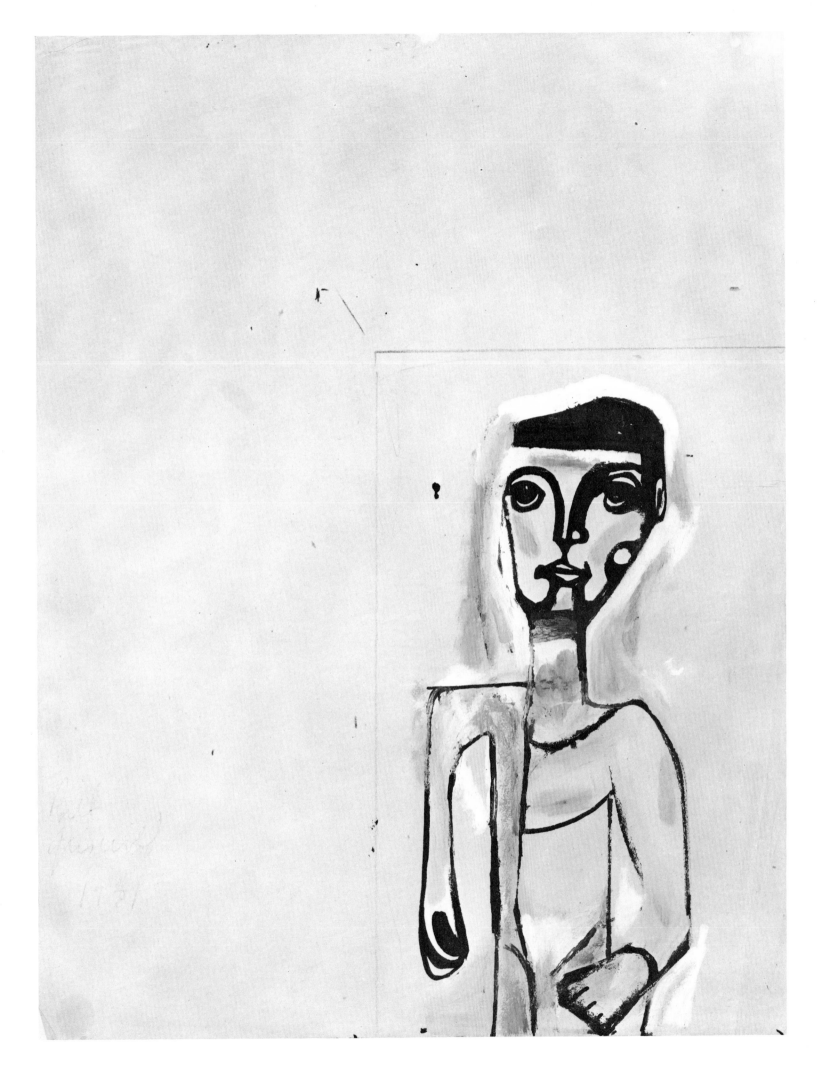

10. *Bill Griswold,* 1949. Gouache, 10½ × 8¼ in.

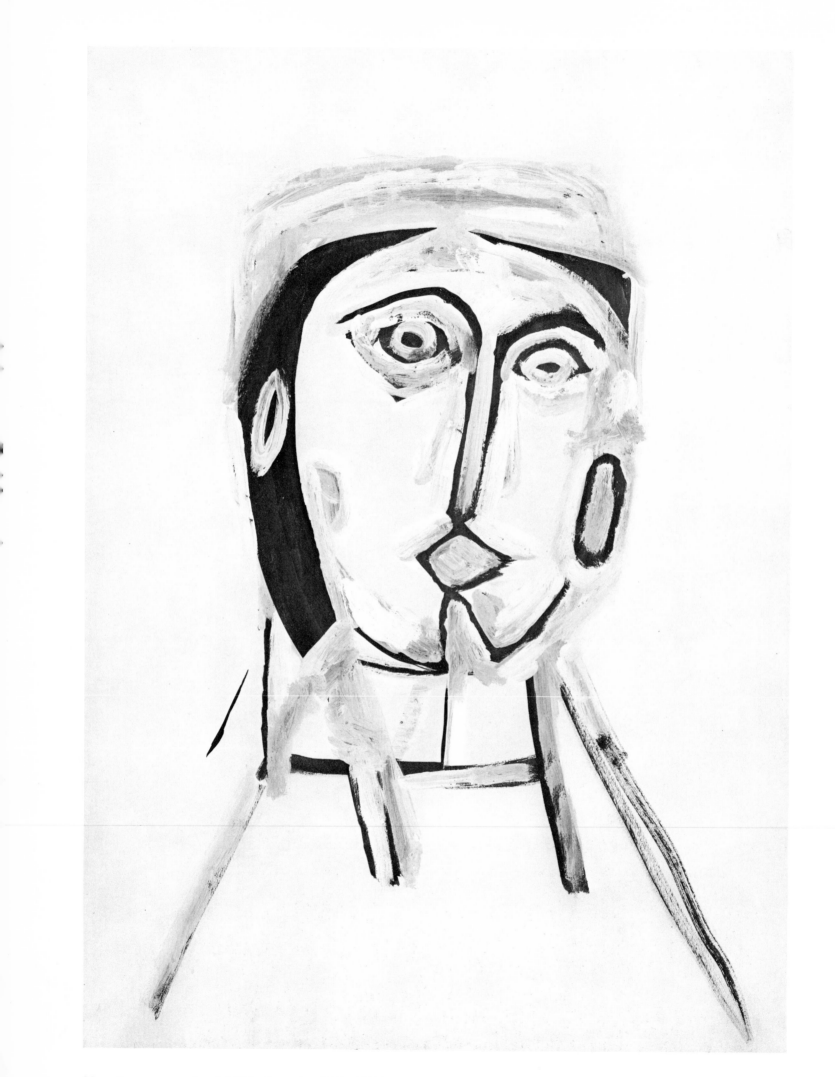

11. *Romanesque head,* 1949. Gouache, 16½ × 12⅛ in.

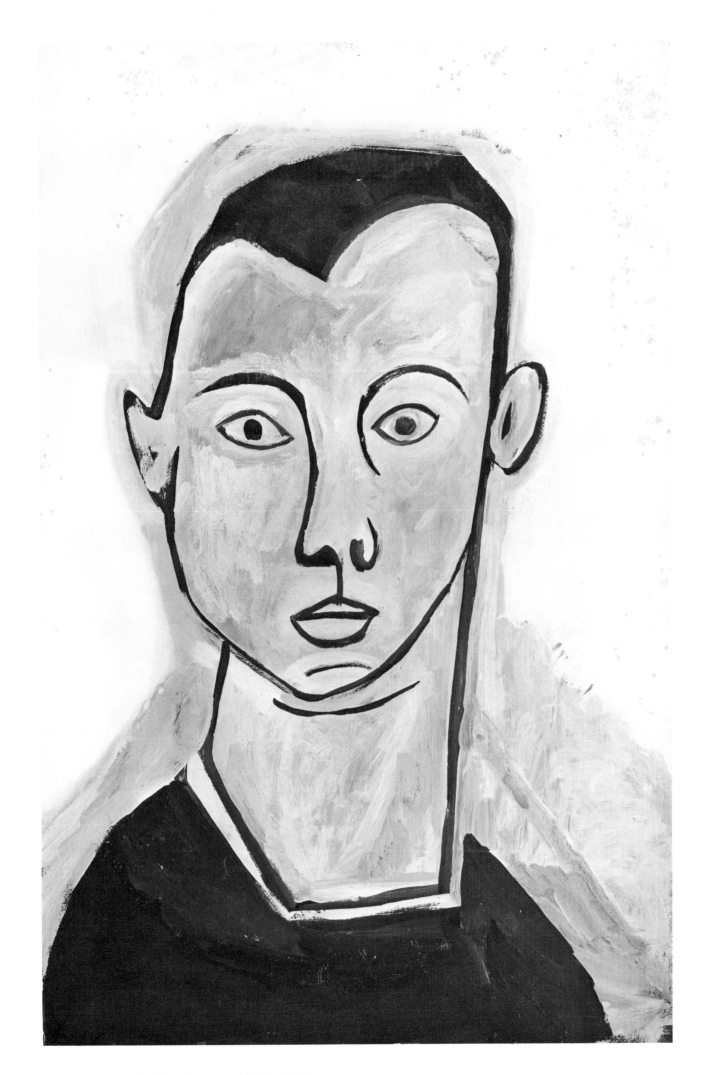

12. *Self-portrait,* 1949. Gouache, 18¾ × 12½ in.

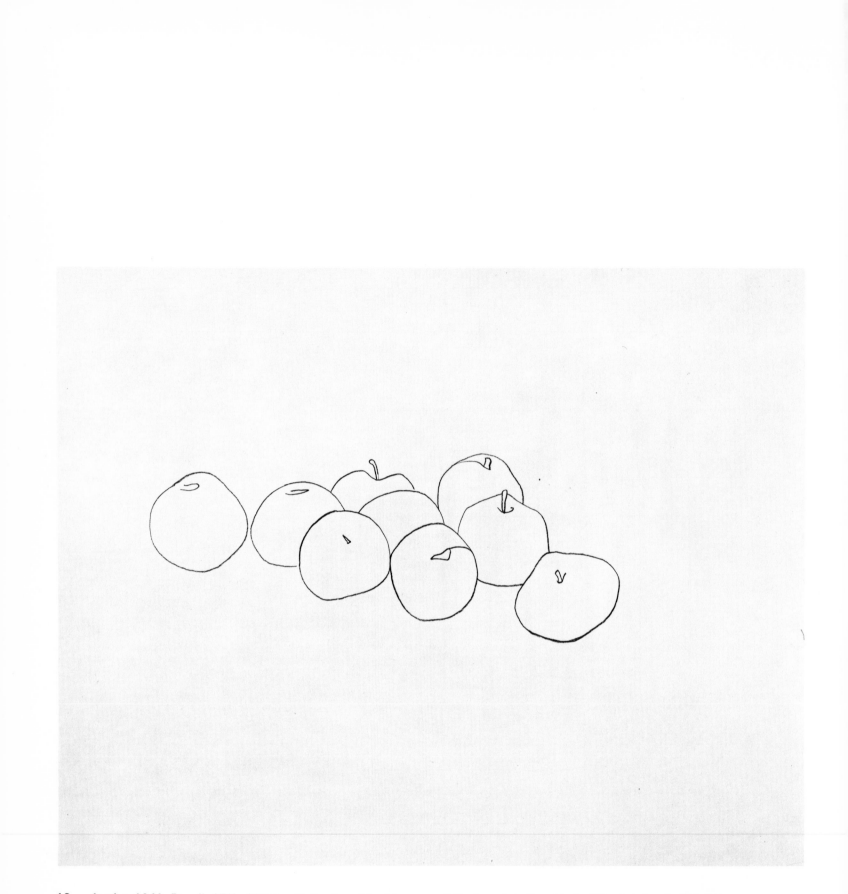

13. *Apples,* 1949. Pencil, 17⅛ × 22⅛ in., Collection: The Museum of Modern Art, New York. Gift of John S. Newberry.

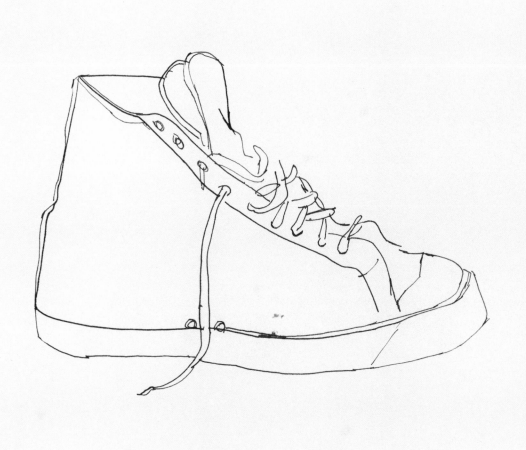

14. *Sneaker*, 1949. Ink, 12¼ × 17¼ in.

16. *Head with beard,* 1949. Newspaper cut-out, 10¼ × 6¼ in.

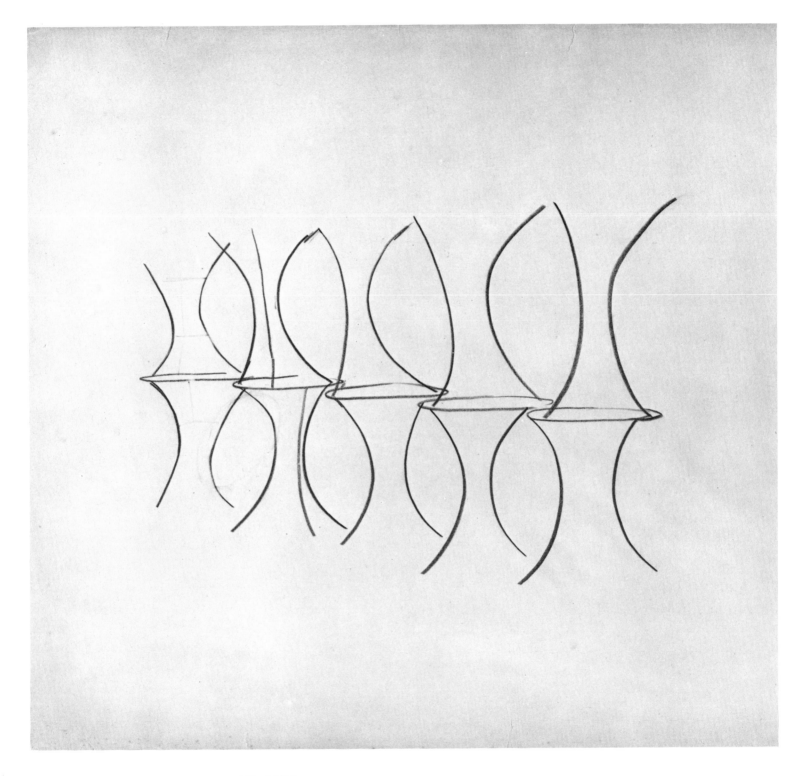

19. *Stacked tables,* 1949. Pencil, 13⅛×14¼ in.

20. *Three trees,* 1950. Pencil, 17⅝ × 12⅜ in.

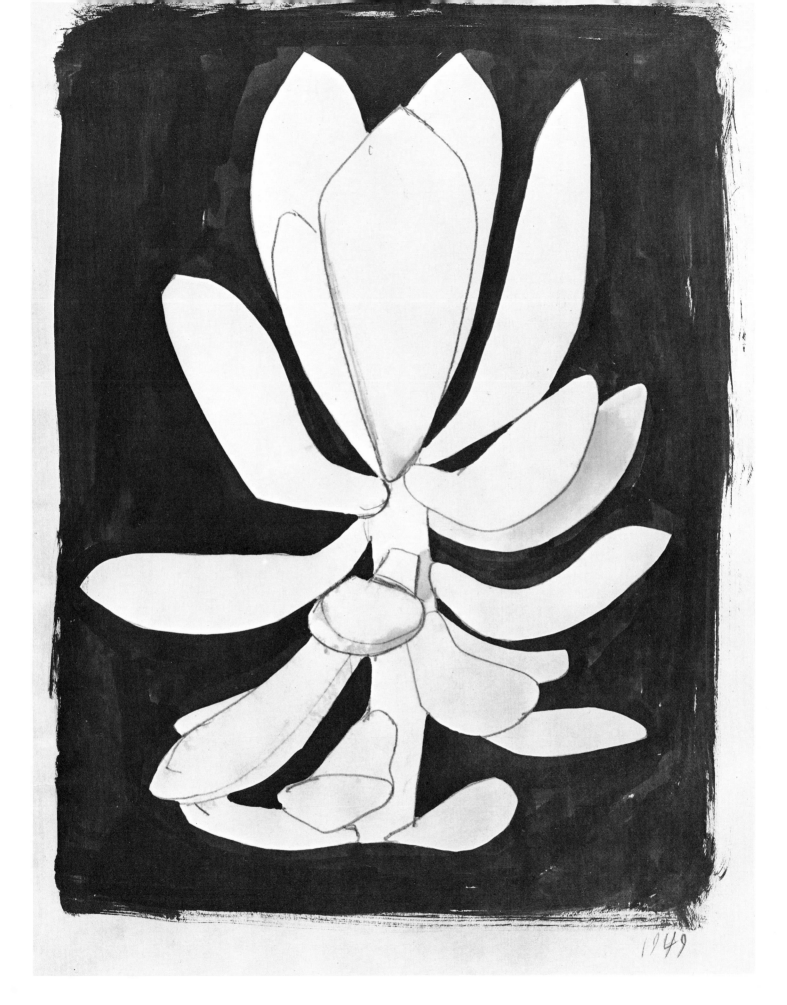

1949

21. *Study for PLANT I,* 1949. Ink, pencil, 12¾ × 9¼ in.

22. *Study for WINDOW, MUSEUM OF MODERN ART, PARIS,* 1949. Ink, pencil, 16½ × 12⅛ in.

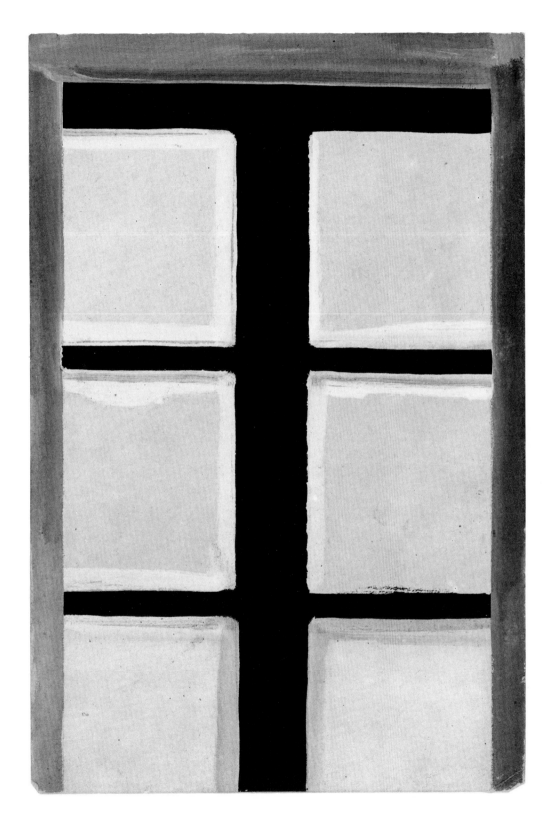

23. *Study for WINDOW I*, 1949. Gouache, 8×5⅝ in.

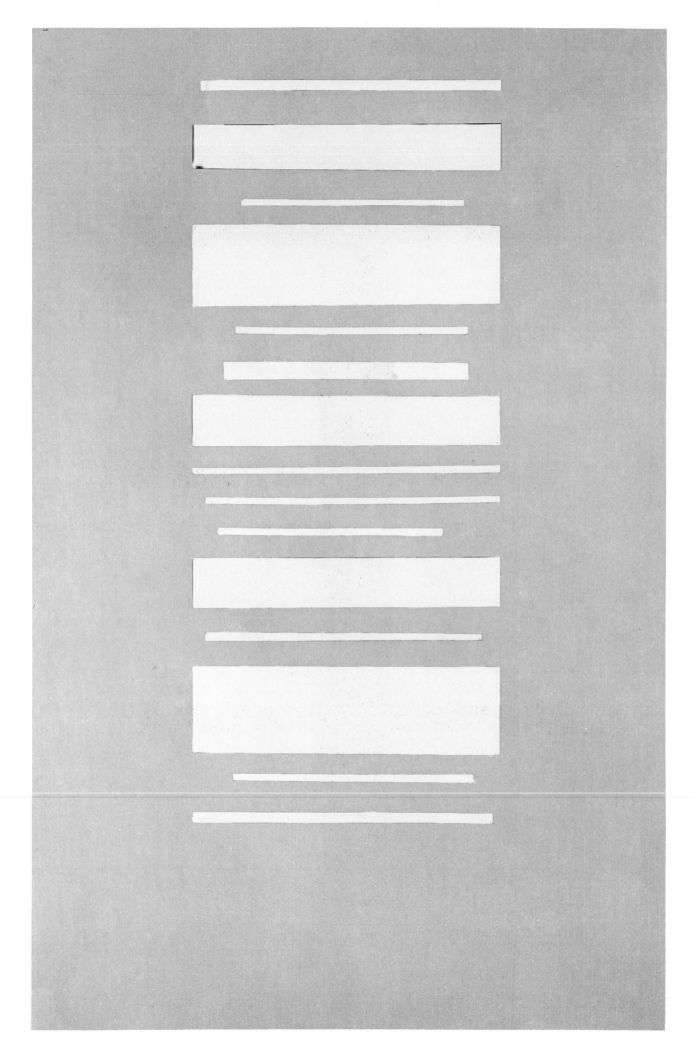

24. *White fragments,* 1950. Collage, 29¾ × 19⅝ in.

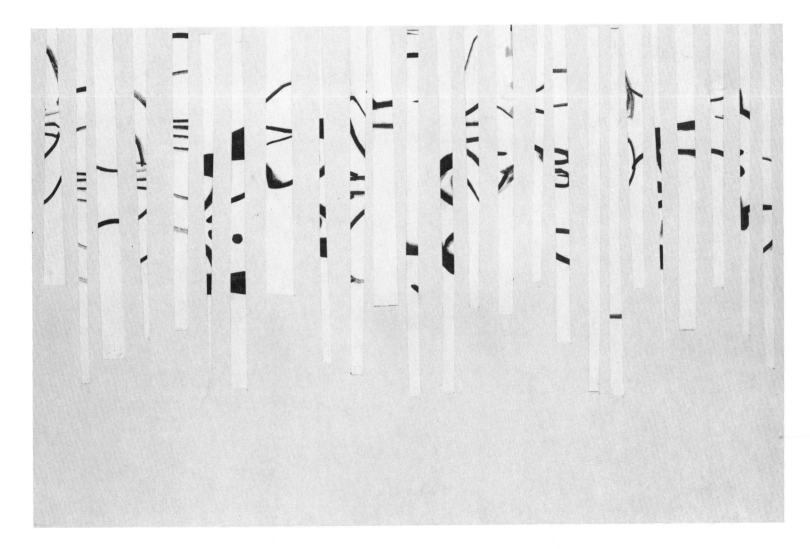

28. *Drawing cut into strips and rearranged by chance (one of three parts),* 1950. Ink, collage, 16½ × 25¾ in.

29. *Automatic drawing: Coat hangers,* 1950. Pencil, 8 × 3⅜ in.

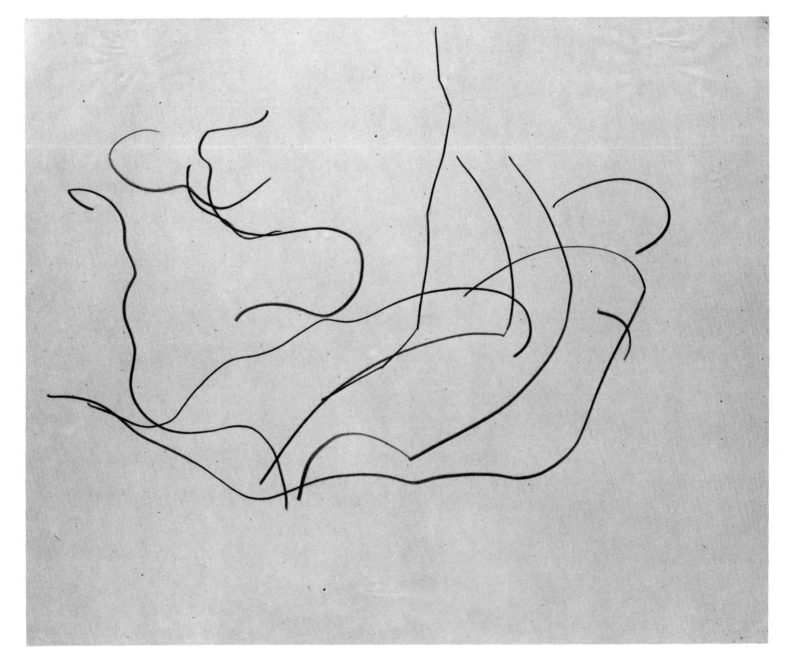

30. *Automatic drawing: Pine branches,* 1950. Pencil, 16⅜ × 20¼ in.

31. *Automatic drawing: Shelled bunker,* 1950. Pencil, 10½ × 13⅜ in.

32. *Fields on a map,* 1950. Pencil, 5¾ × 13⅜ in.

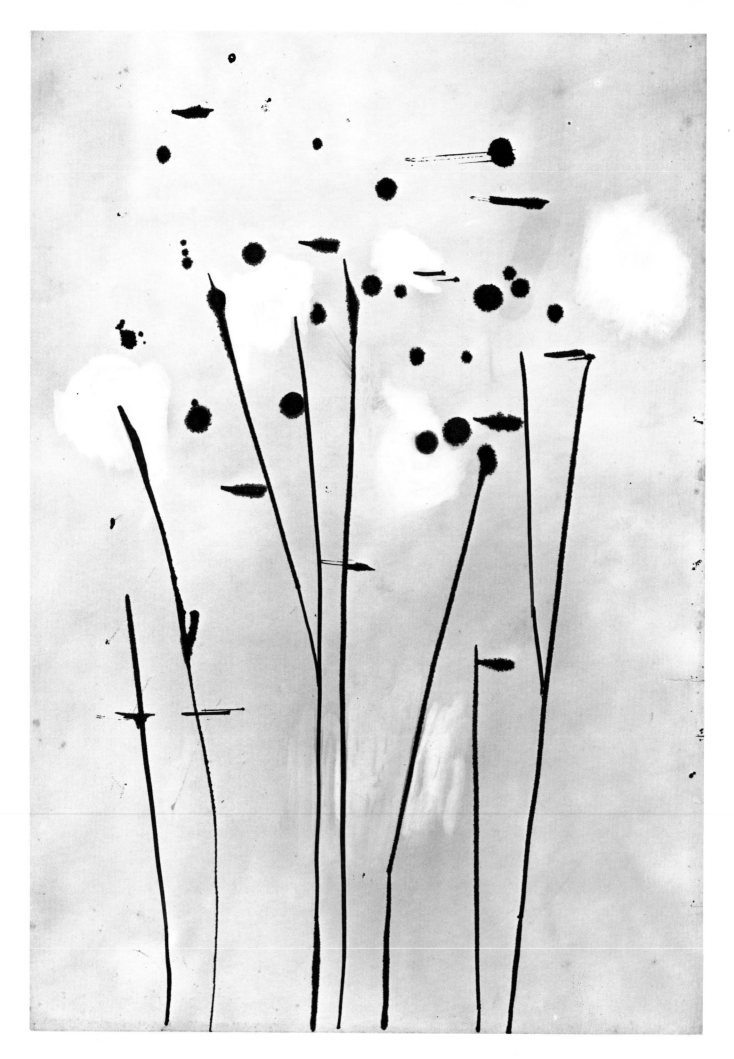

33. *Autumn trees,* 1950. Ink, 17¾ × 12½ in.

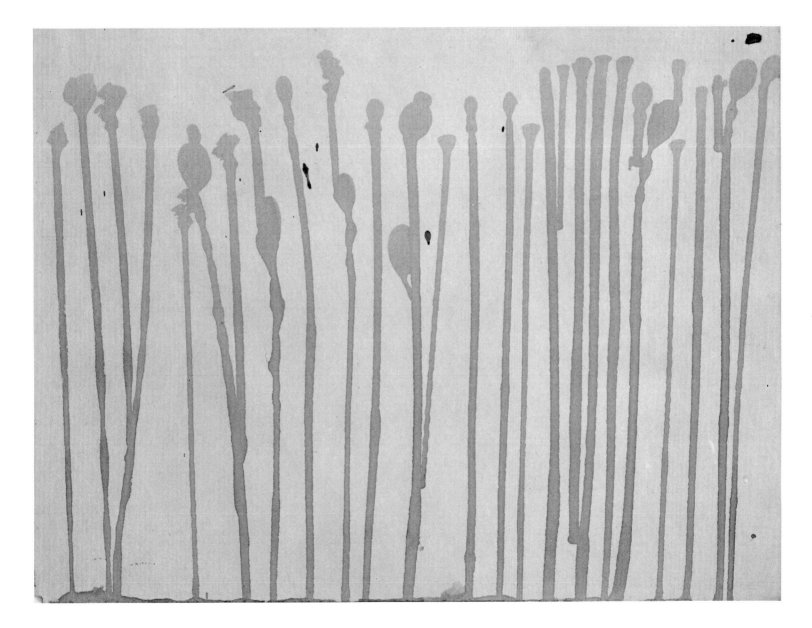

34. *Grass,* 1950. Ink, 9¼ × 12⅛ in.

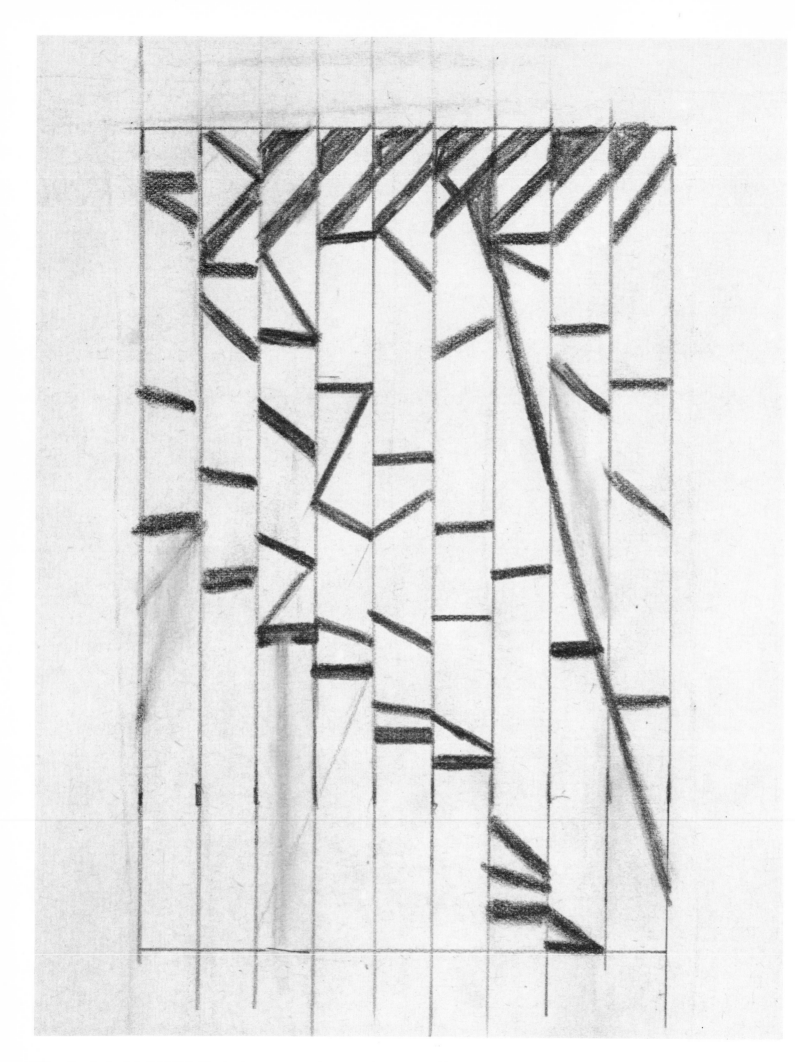

35. *Study for LA COMBE III, shadows on a staircase,* 1950. Pencil, 7¼ × 5 in.

36. *Pages from a magazine,* 1950. Collage of printed paper, 15½ × 1¼ in.

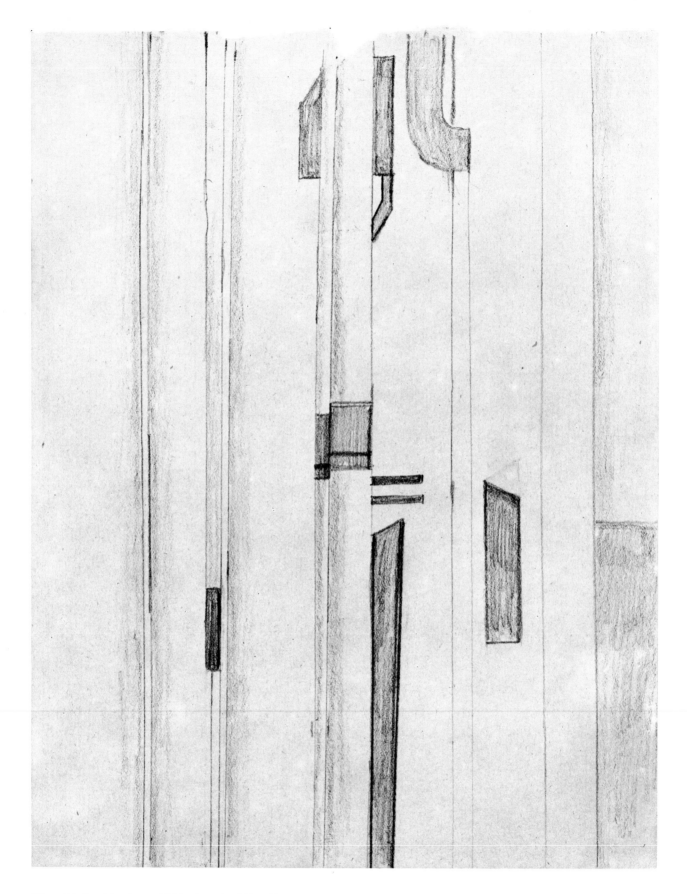

37. *Wall with pipes,* 1950. Pencil, 8¾ × 6¾ in.

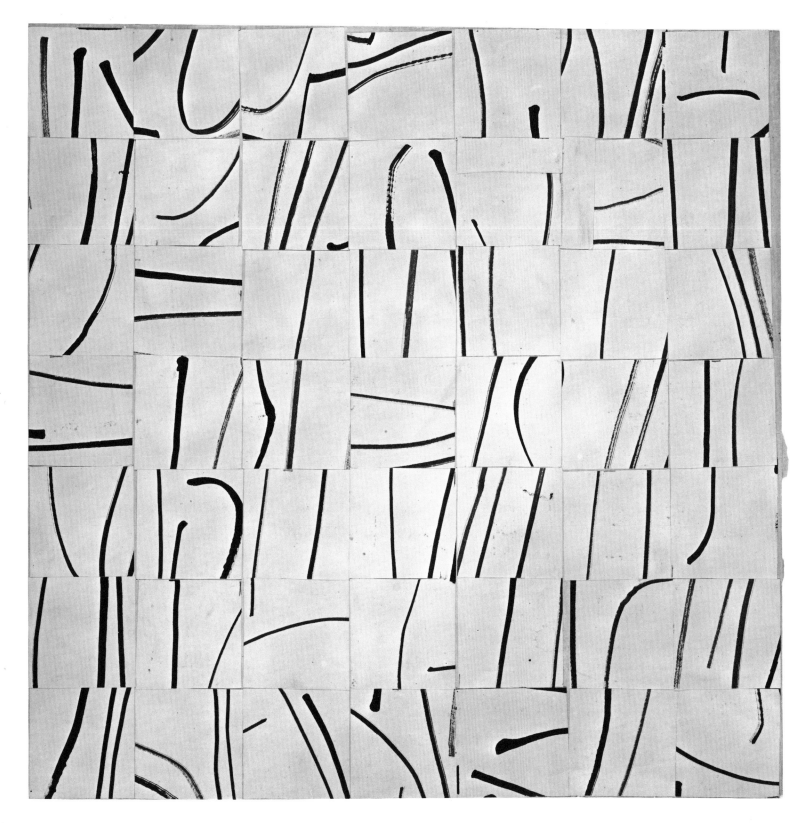

41. *Brush strokes cut into 49 squares and arranged by chance,* 1951. Ink, collage, 13¾ × 14 in.

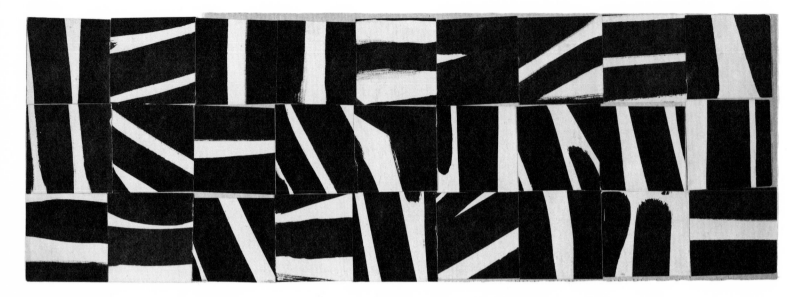

42. *Brush strokes cut into 27 squares and arranged by chance,* 1951. Ink, collage, 4¾ × 14 in.

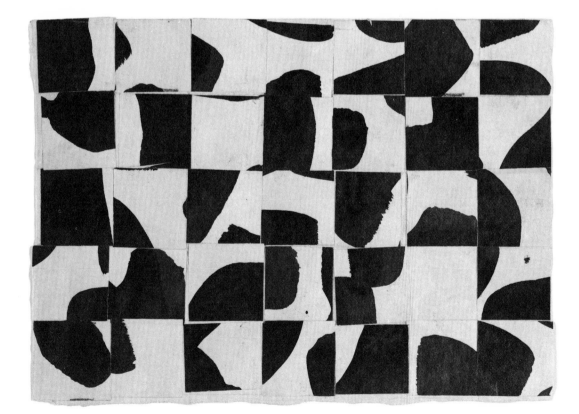

43. *Brush strokes cut into 35 squares and arranged by chance,* 1951. Ink, collage, 4 × 5⅝ in.

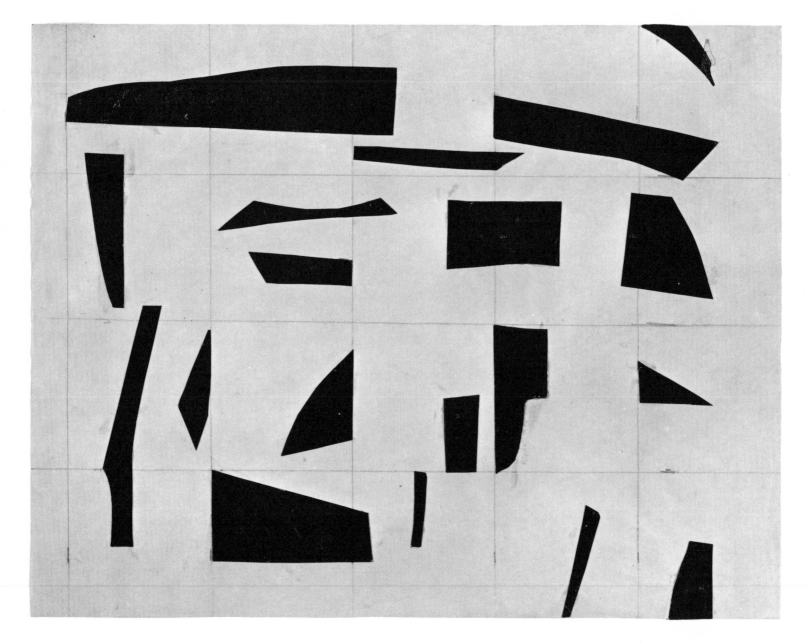

44. *Study for MOBY DICK, red pieces arranged on a grid*, 1951. Pencil, collage, 8×10½ in.

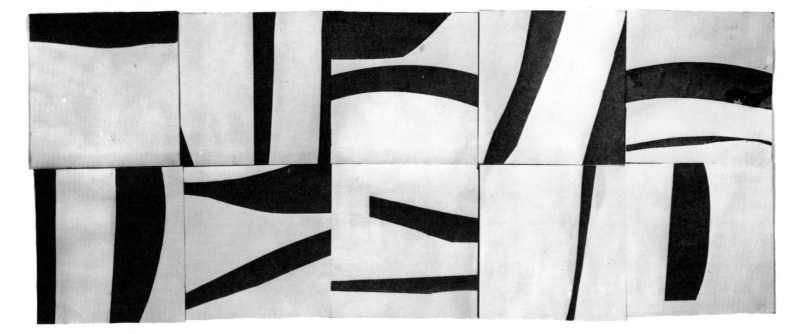

45. *Study for GREEN WHITE, green collage strips cut into 10 squares and arranged by chance,* 1951. Collage, 9⅝ × 24½ in.

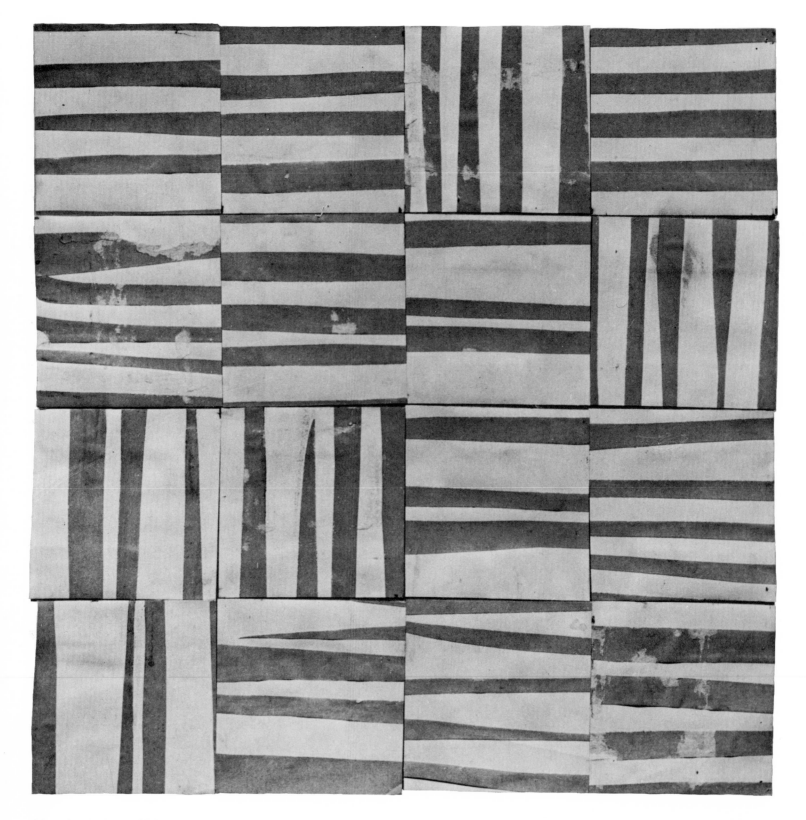

46. *Study for YELLOW WHITE, yellow collaged strips cut into 16 squares and arranged by chance,* 1951. Collage, 11¾ × 11⅞ in.

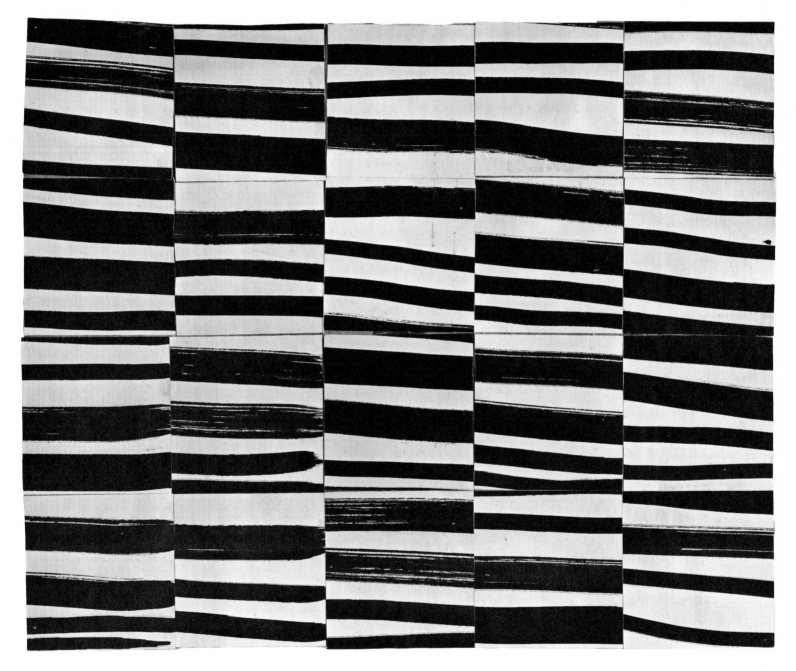

47. *Study for CITÉ, brush strokes cut into 20 squares and arranged by chance*, 1951. Ink, collage, 12¼×15⅛ in.

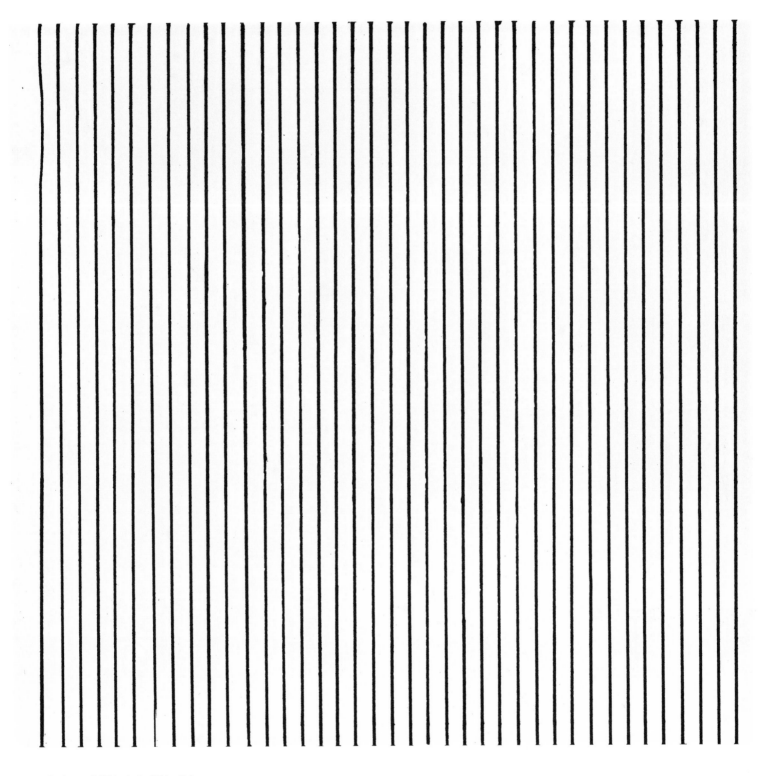

49. *Stripes,* 1951. Ink, 7½ × 8 in.

This drawing and the five following drawings are from LINE, FORM AND COLOR, a book proposed by the artist in 1951.

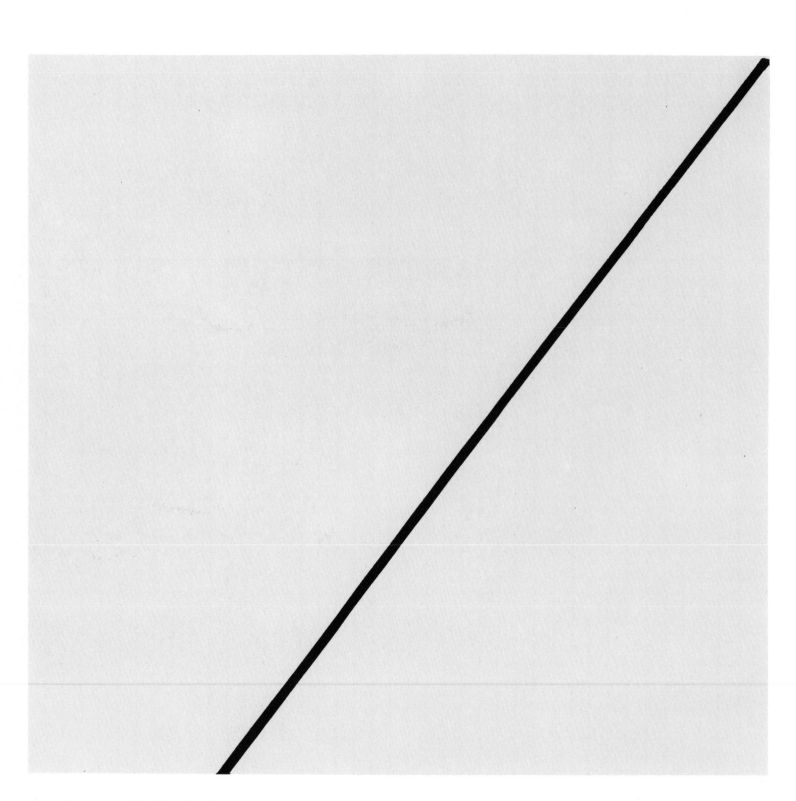

50. *Diagonal,* 1951. Ink, 7½ × 8 in.

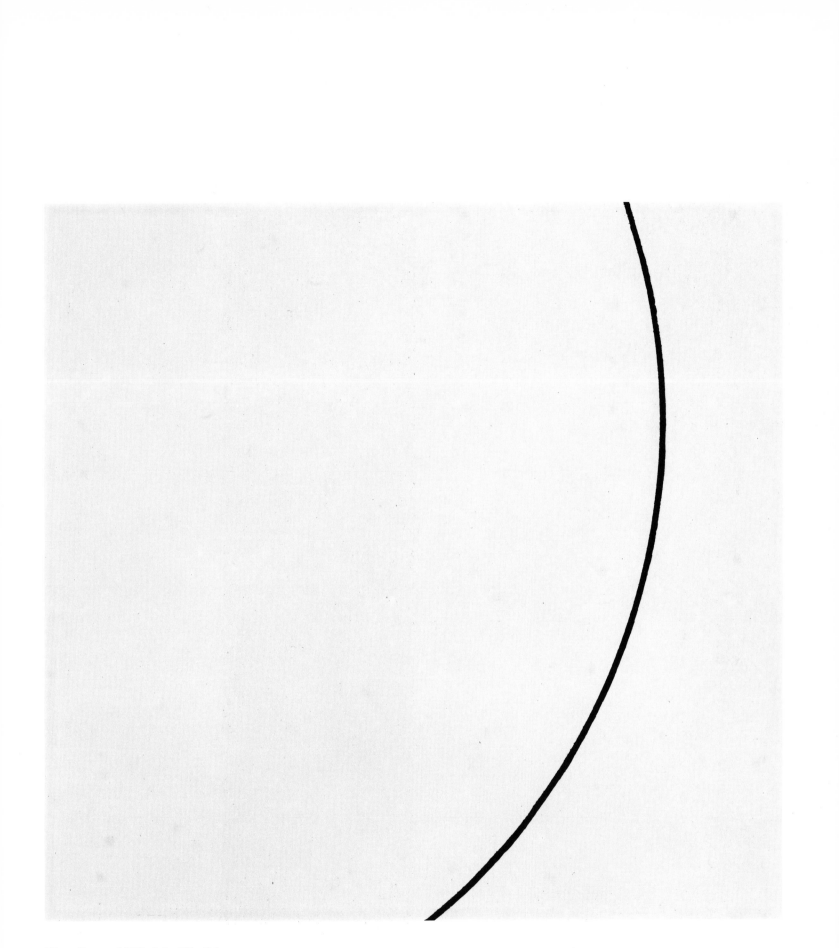

51. *Curve,* 1951. Ink, 7½ × 8 in.

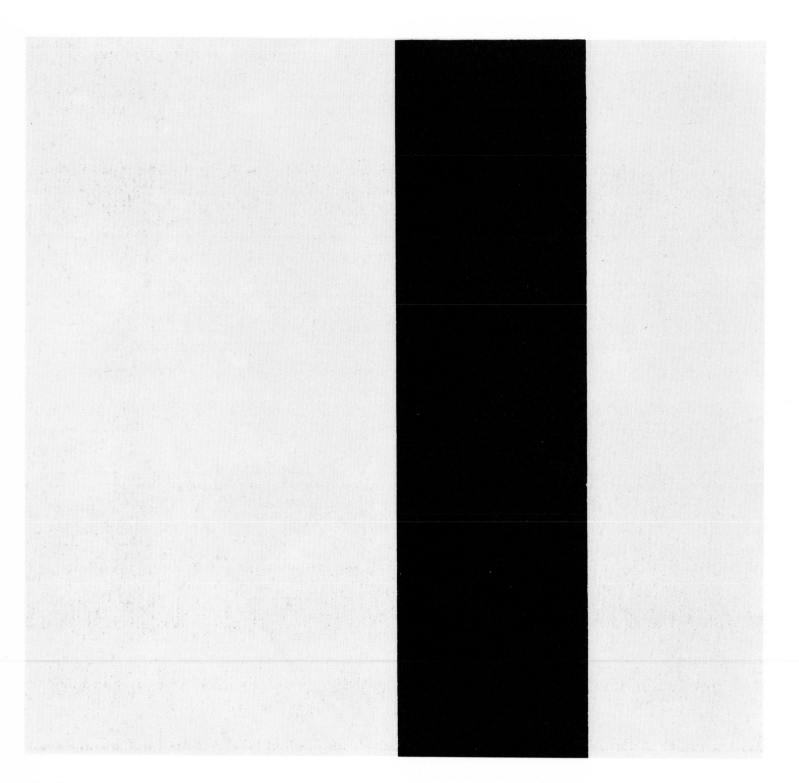

52. *Vertical band,* 1951. Collage, 7½ ×8 in.

53. *Horizontal band,* 1951. Collage, 7½ × 8 in.

55. *Study for WHITE PLAQUE, BRIDGE ARCH AND REFLECTION*, 1951. Collage, 20¼×14¼ in.

56. *Study for SEINE, chance diagram of light reflected on water,* 1951. Ink, pencil, 4¾ × 15⅞ in.

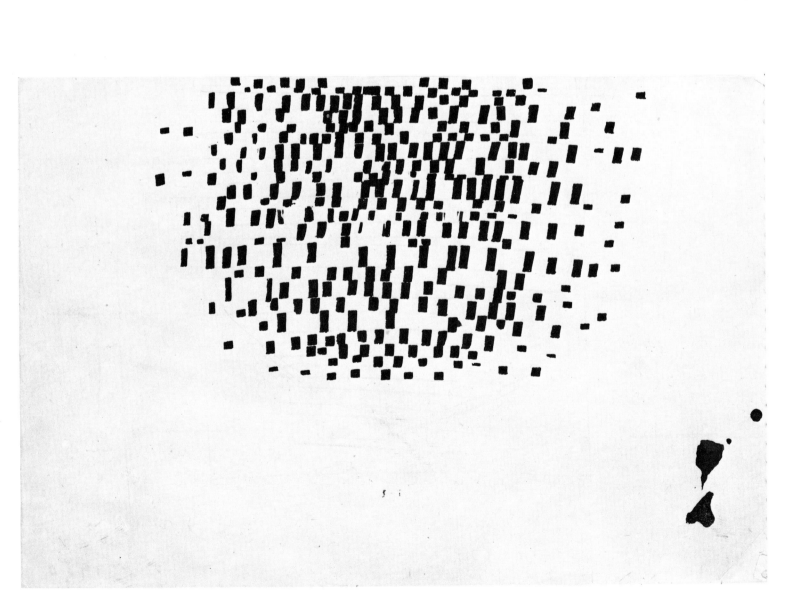

57. *Reflection on water I,* 1950. Ink, 5¼×8¼ in.

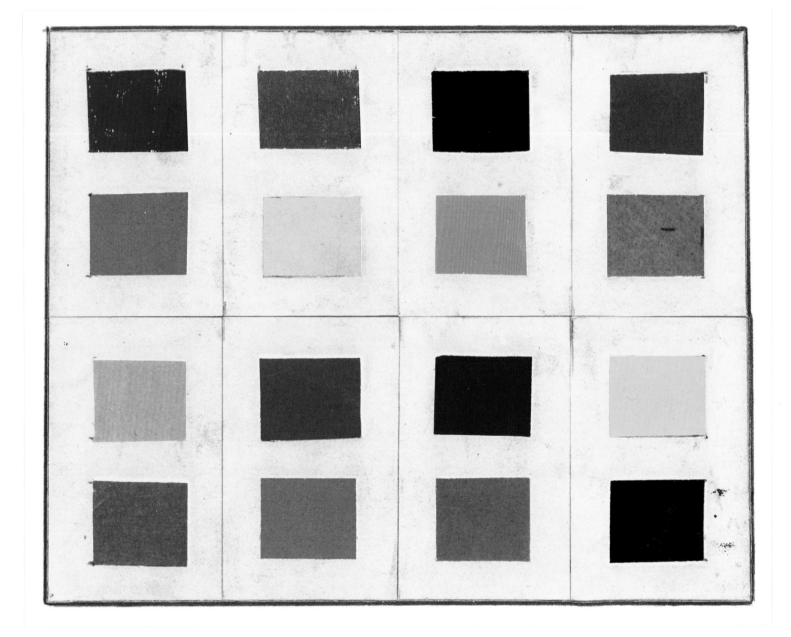

62. *Eight color pairs,* 1951. Pencil, collage, 12¼×17¾ in.

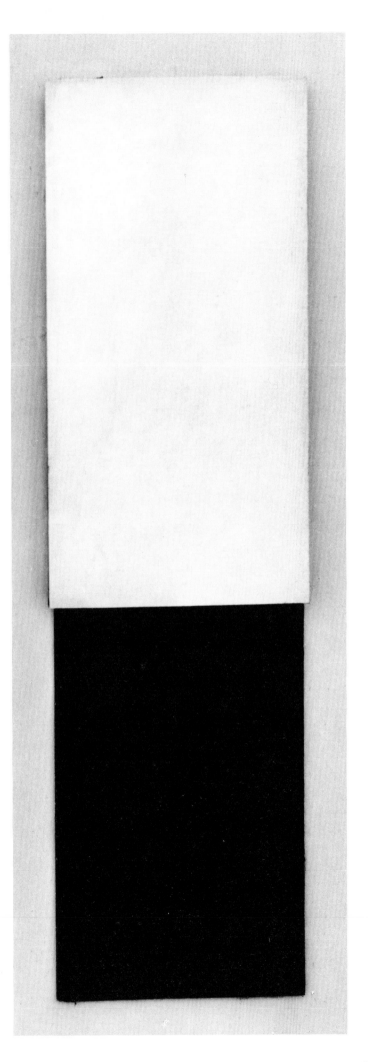

72. *Study for TWO PANELS: WHITE OVER BLUE,* 1952. Collage, relief, 9½ × 2⅝ × ⅜ in.

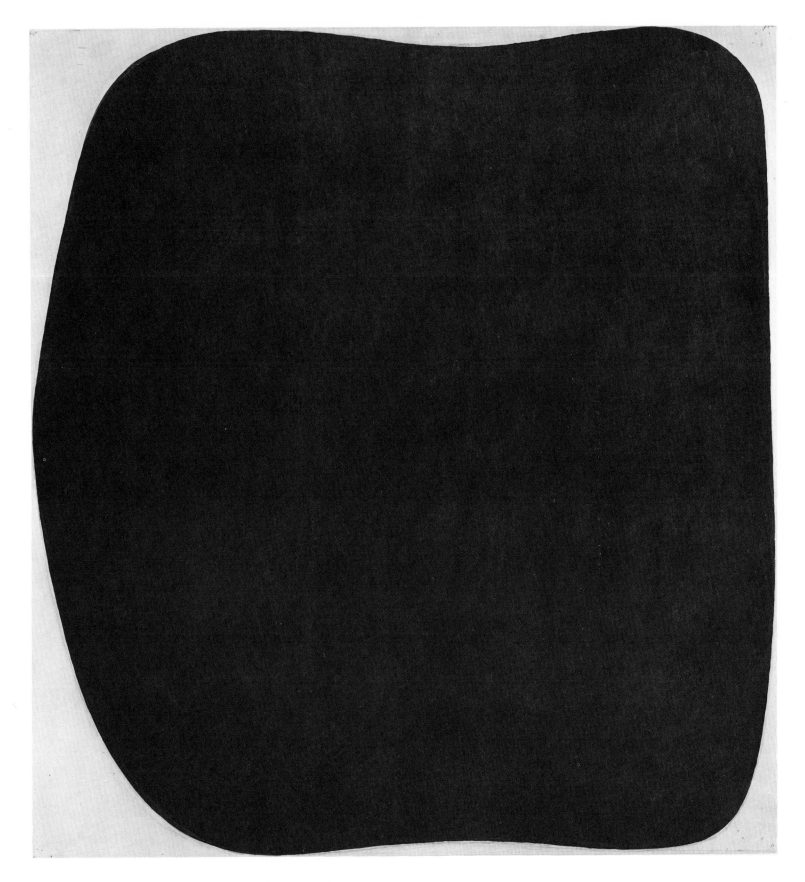

86. *Preliminary study for BLACK RIPE,* 1954. Ink, 20⅝ × 19¼ in.

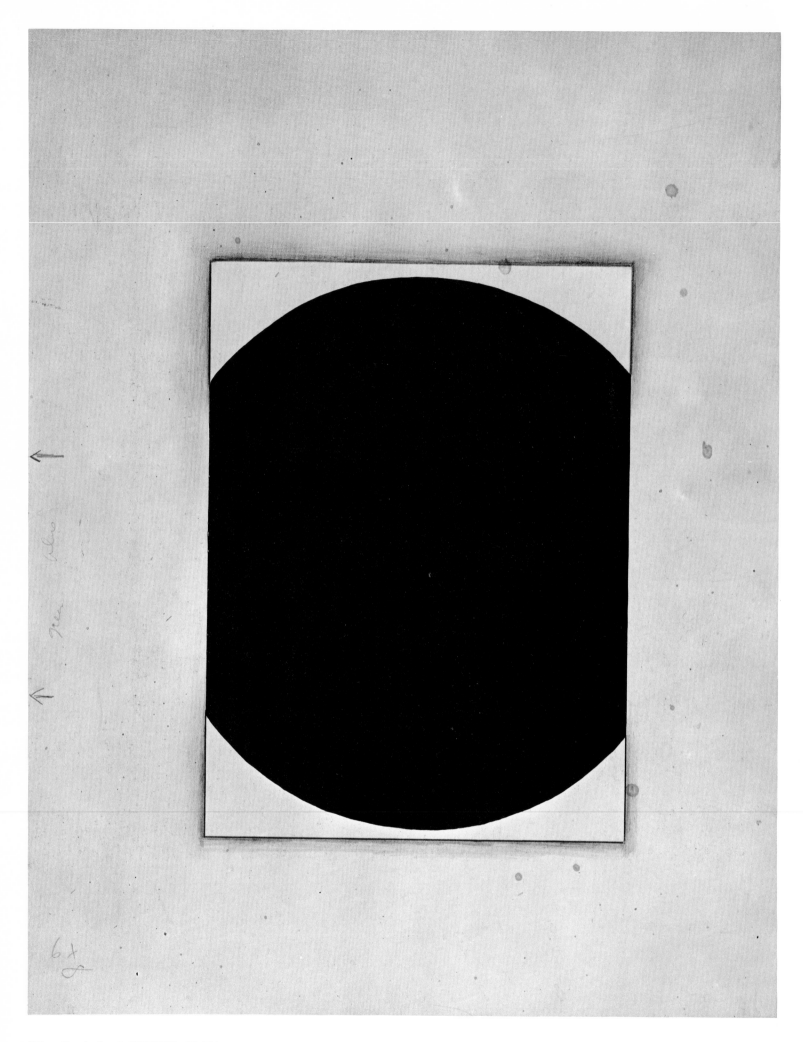

87. *Study for PAINTING IN THREE PANELS,* 1955. Ink, pencil, 13¾ × 10⅞ in.

88. *Preliminary study for WALL,* 1955. Collage, 10⅛ × 9 in.

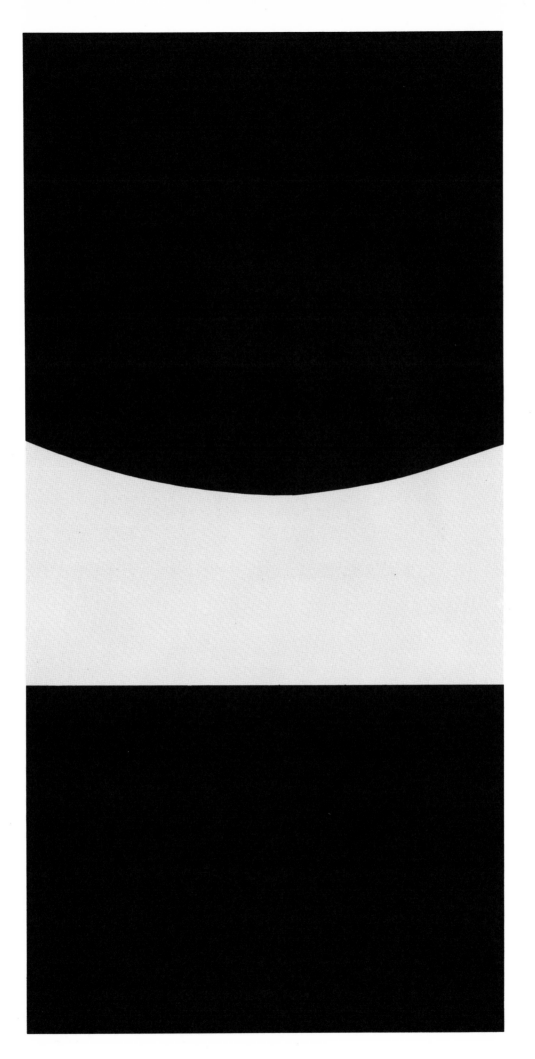

94. *White form on black,* 1955. Collage, 13¾ × 6¾ in.

95. *Brooklyn Bridge,* 1957. Ink, pencil, 10×8 in.

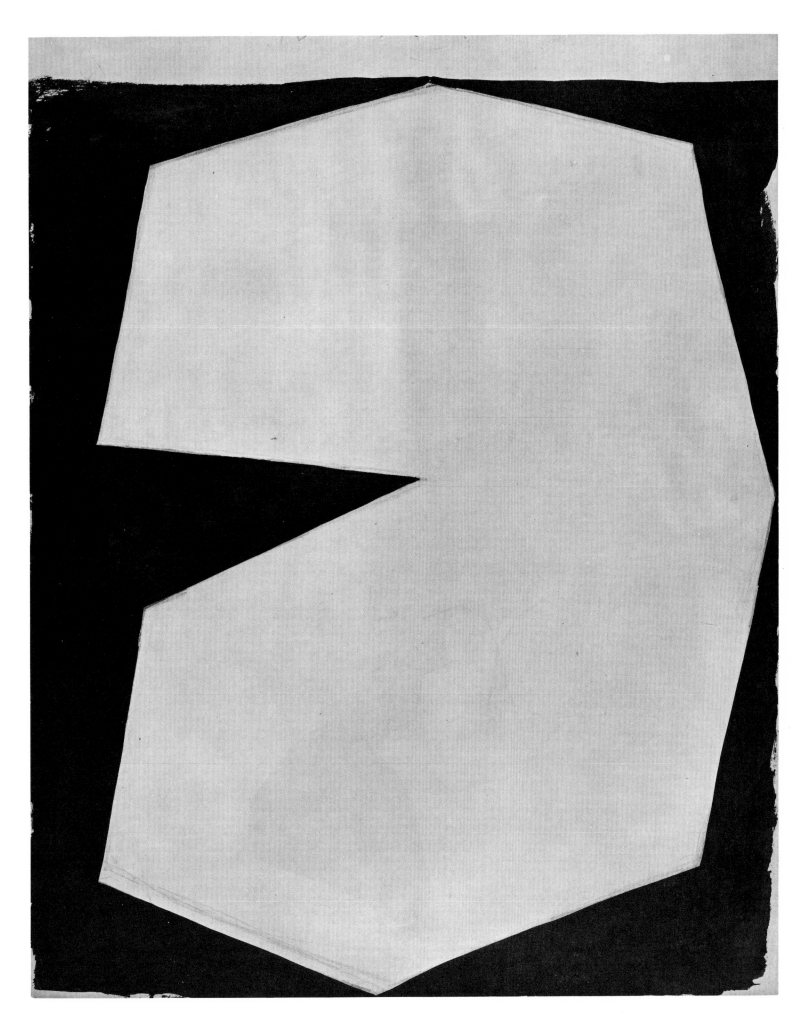

96. *White form,* 1956. Ink, 14×11 in.

97. *Sketch for whites hinged on black,* 1956. Ink, pencil, 8½ × 3⅜ in.

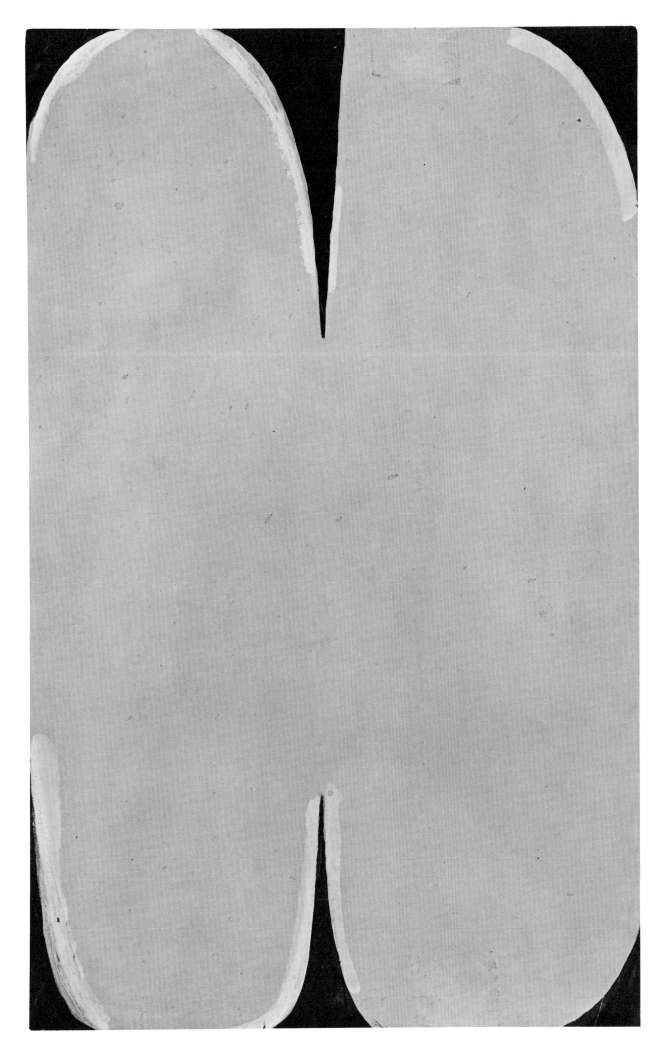

98. *Study for POLE,* 1956. Ink, gouache, 11 × 7 in.

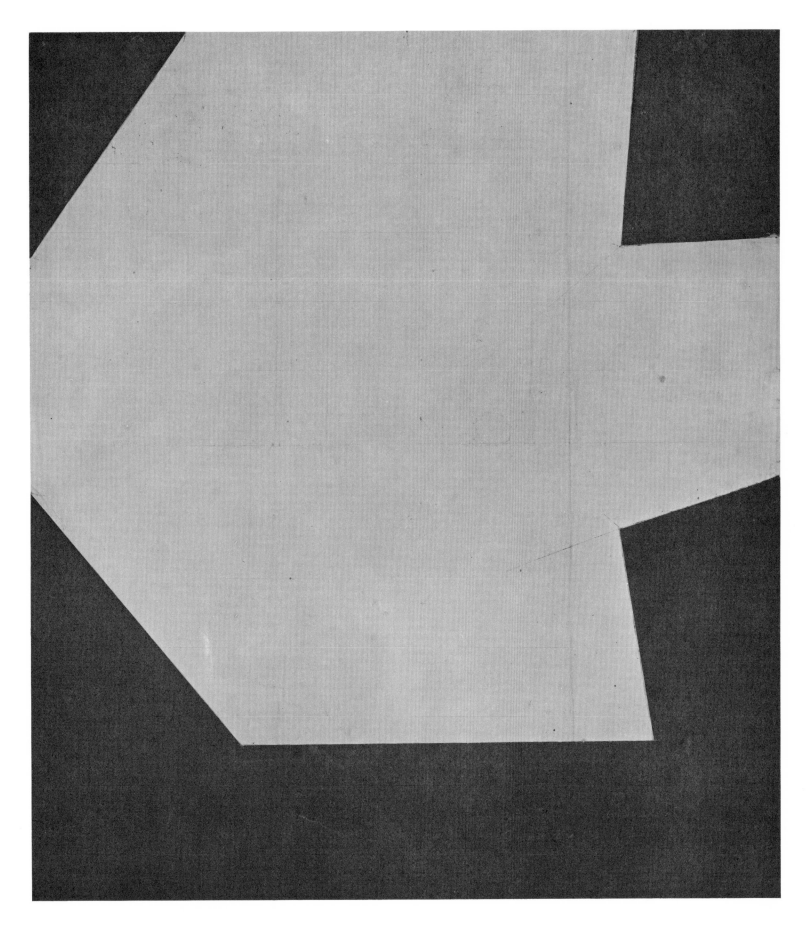

100. *Study for PALM, white on blue,* 1957. Collage, 15⅞ × 14½ in.

101. *Horizontal "A"* 1957. Collage, postcard, 3½ × 5½ in.

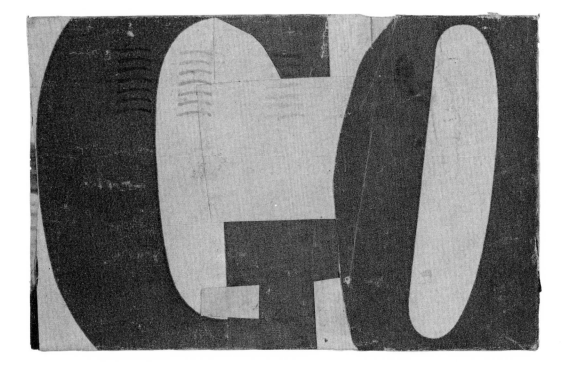

102. *Go,* 1957. Collage, postcard, 3½ × 5½ in.

103. *Four black and whites, upper Manhattan Bay,* 1957. Collage, postcard, 3½ × 5½ in.

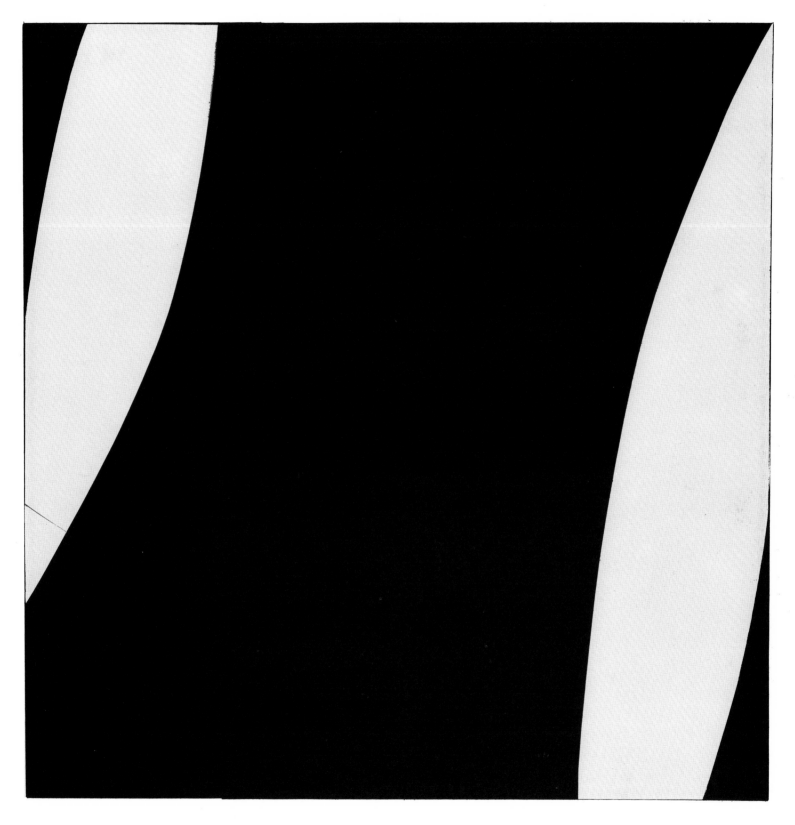

108. *Whites on black,* 1958. Collage, 12×12 in.

109. *Study for a white sculpture,* 1958. Collage, pencil, 14½ × 12⅛ in.

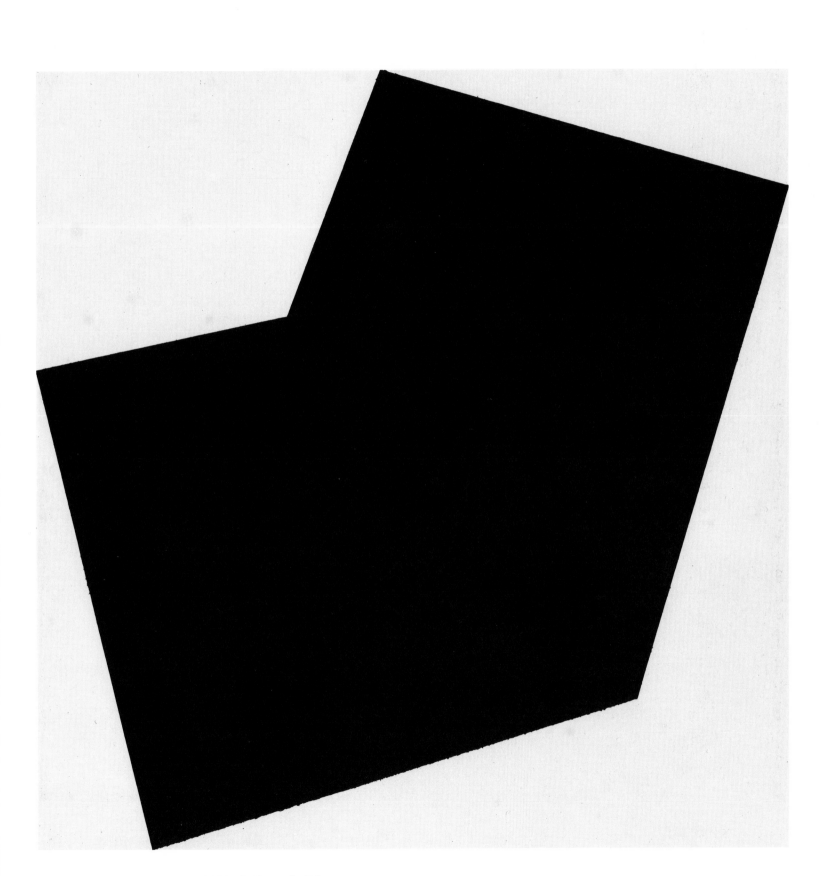

112. *Study for a sculpture*, 1959. Collage, 9 × 9 in.

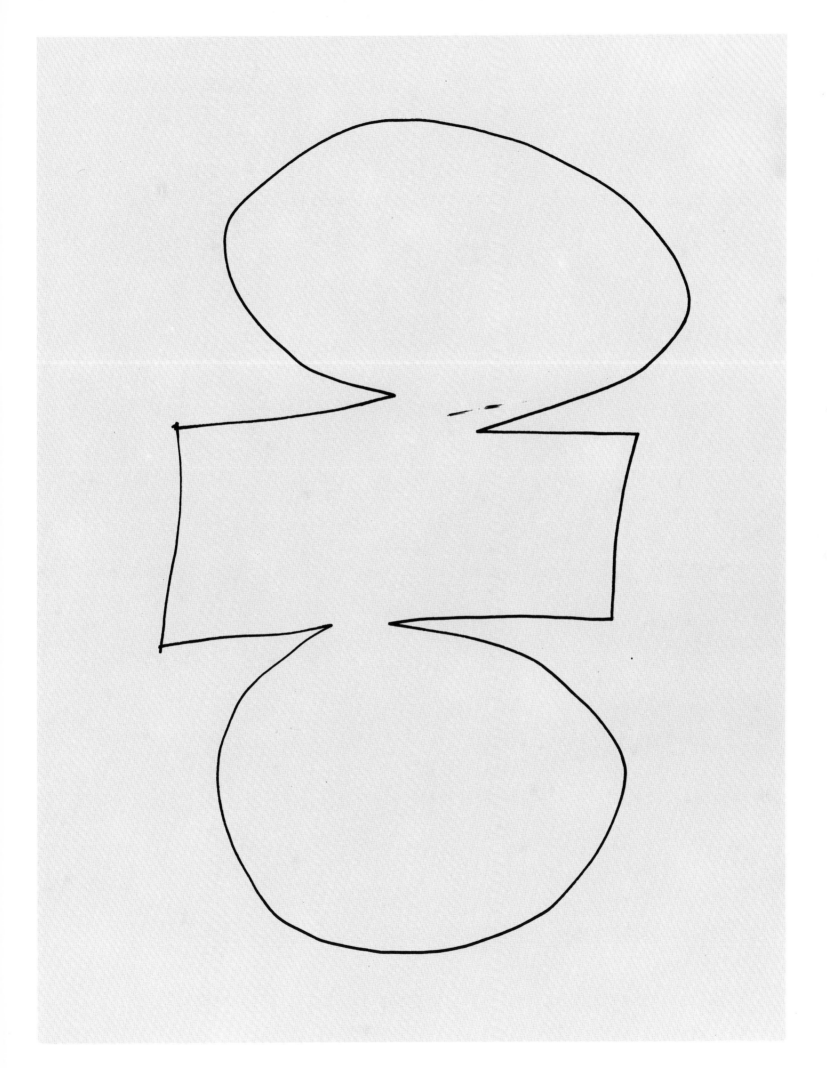

117. *One stroke,* 1959. Ink, 12 × 9 in.

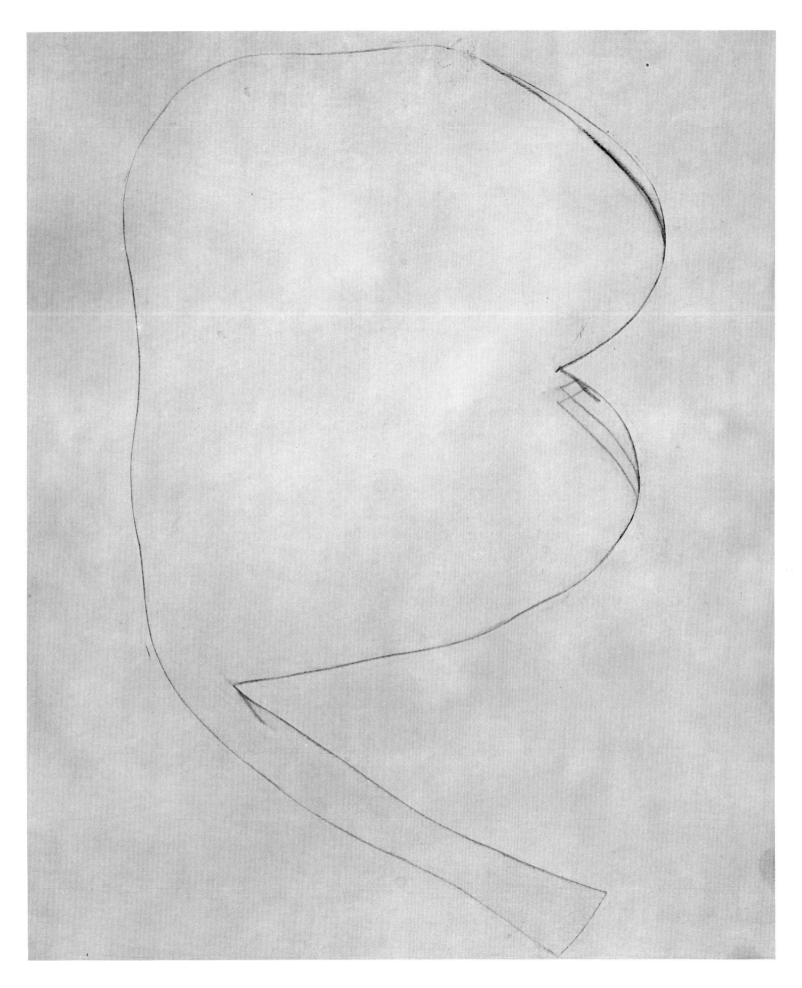

120. *Double form with tail,* 1960. Collage, pencil, 17×14 in.

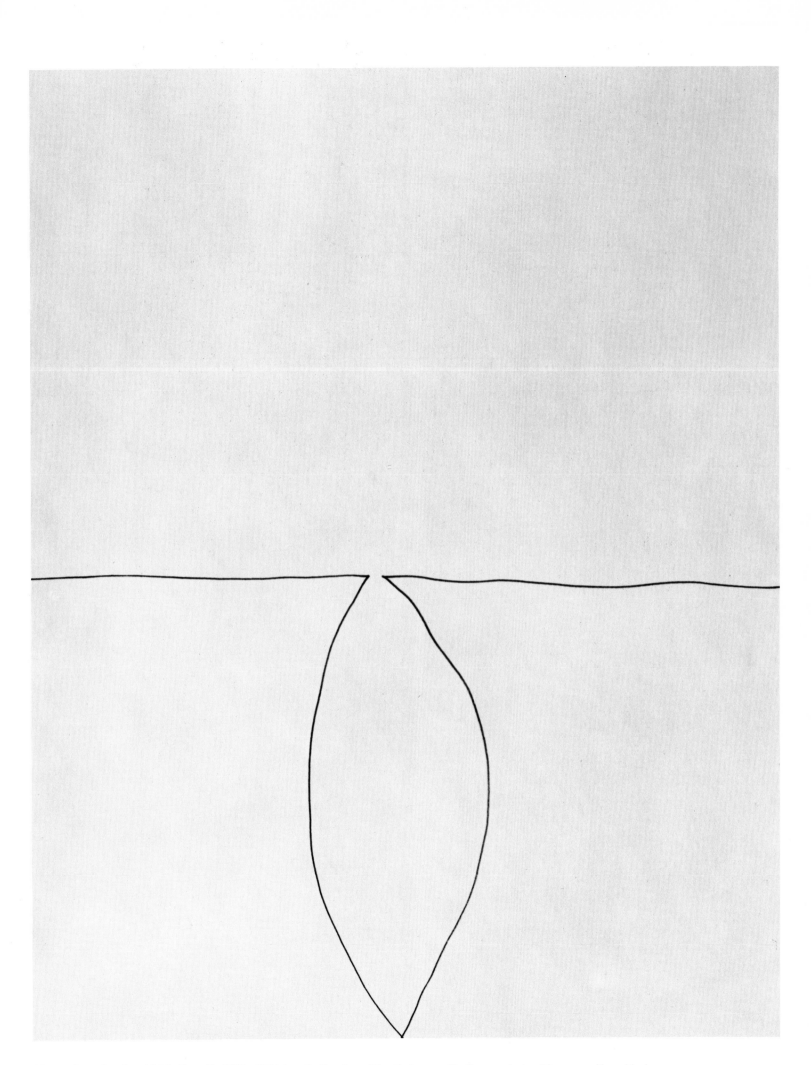

121. *One Stroke,* 1962. Pencil, 28½ × 22½ in., Collection: The Solomon R. Guggenheim Museum, New York.

122. *Double line, Montauk Highway,* 1961. Collage, 14⅛ × 8¼ in.

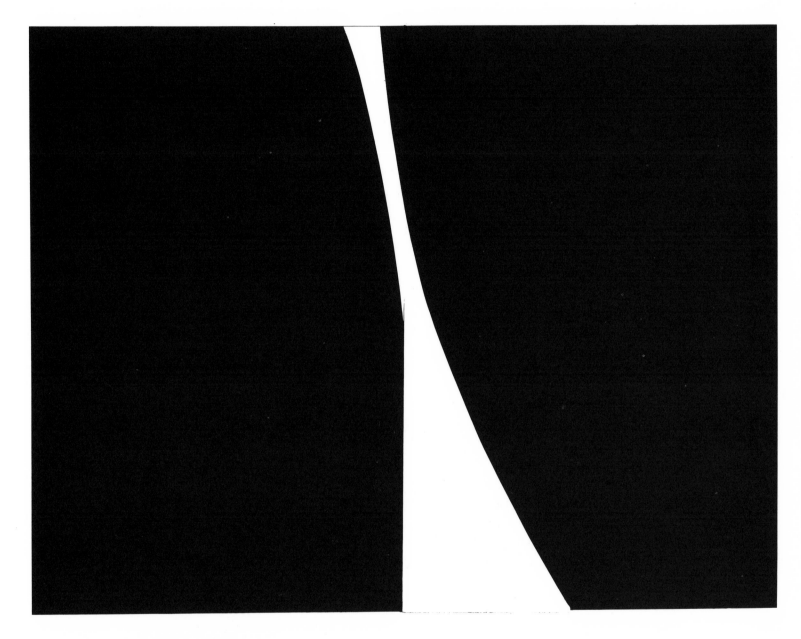

123. *Divided black,* 1961. Collage, 9 × 12 in.

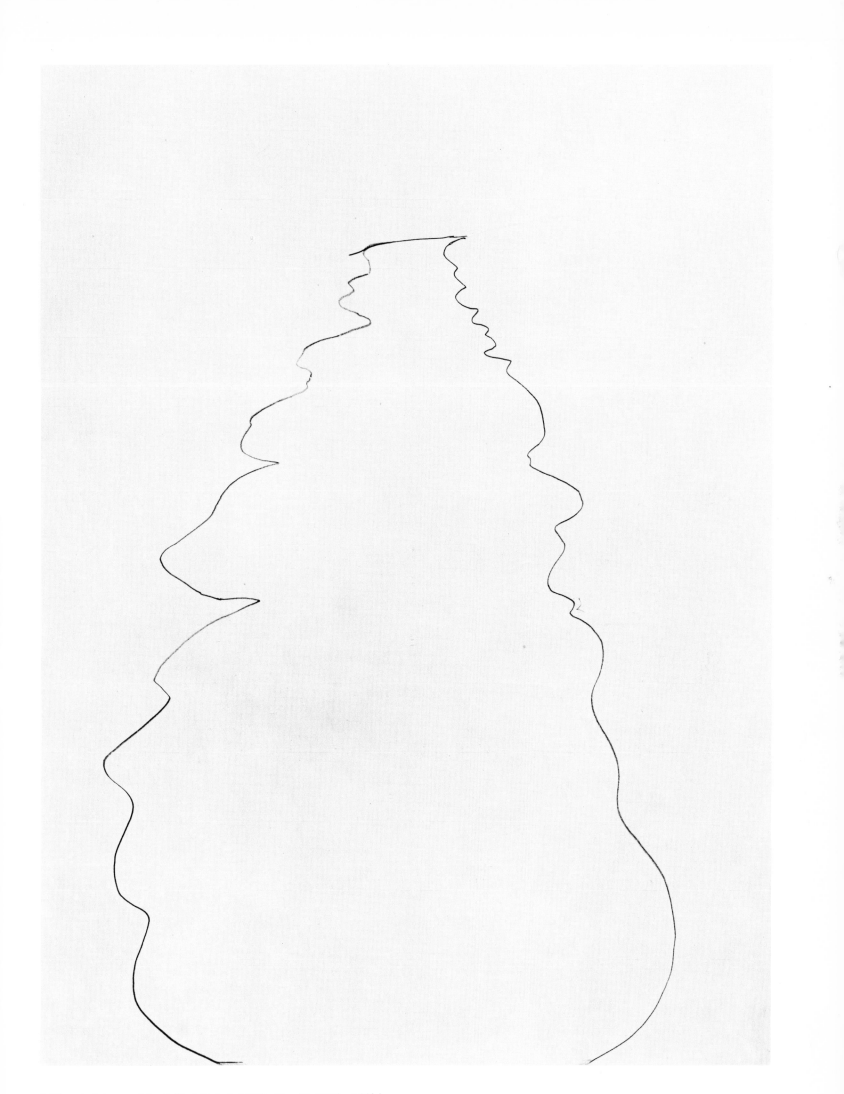

134. *Inlet near Mont St. Michel*, 1965. Pencil, 21½ × 16½ in.

136. *Study for a painting,* 1967. Collage, 11⅛ × 11⅛ in.

Plant Drawings 1959-1969

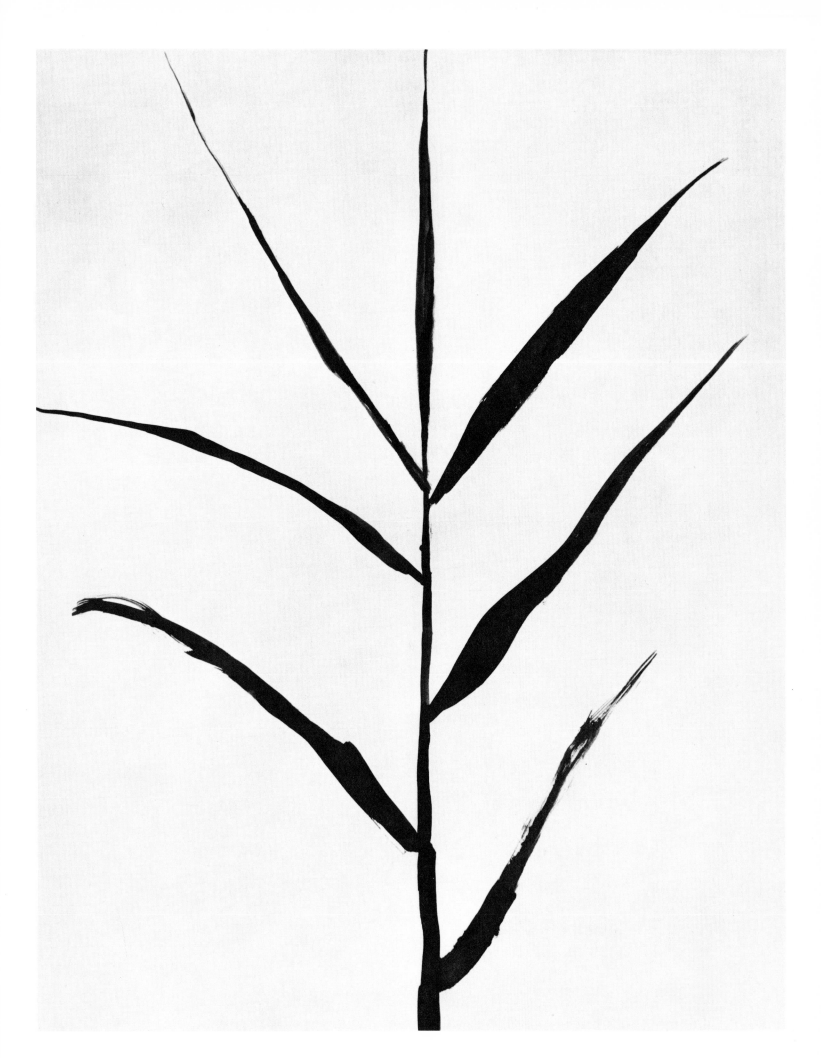

144. *Grass,* 1961. Ink, 28½ × 22½ in.

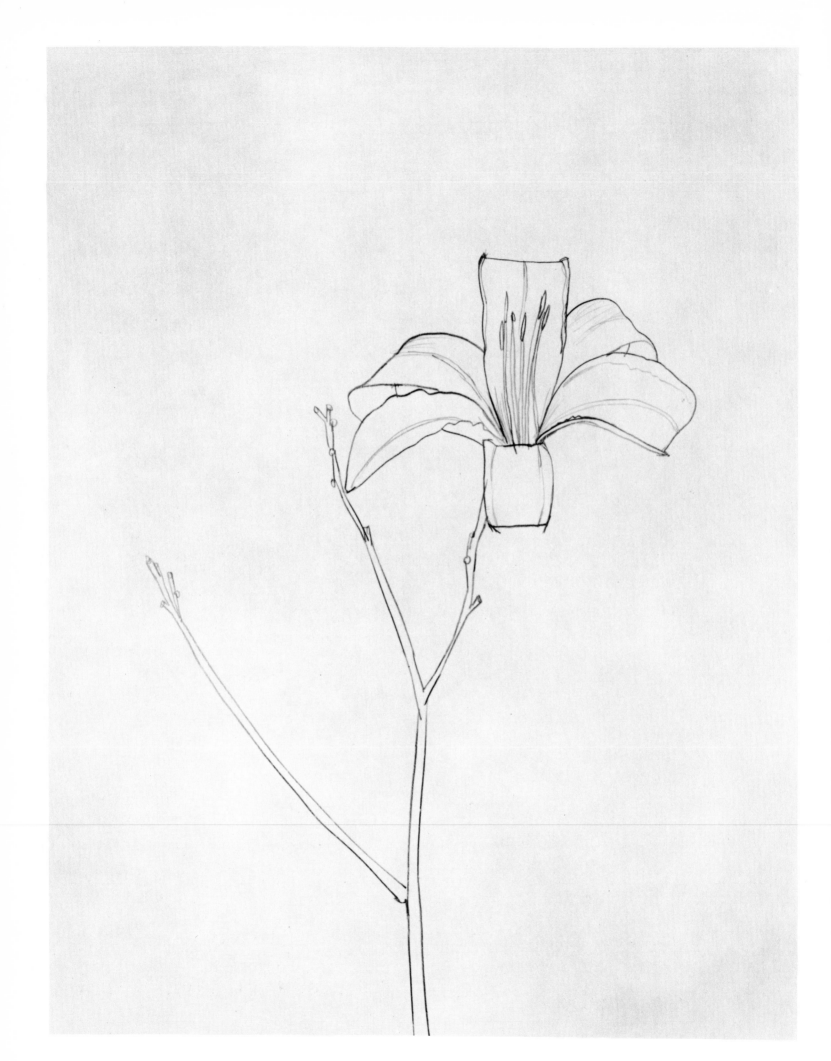

145. *Lily,* 1961. Pencil, 28½ × 22½ in.

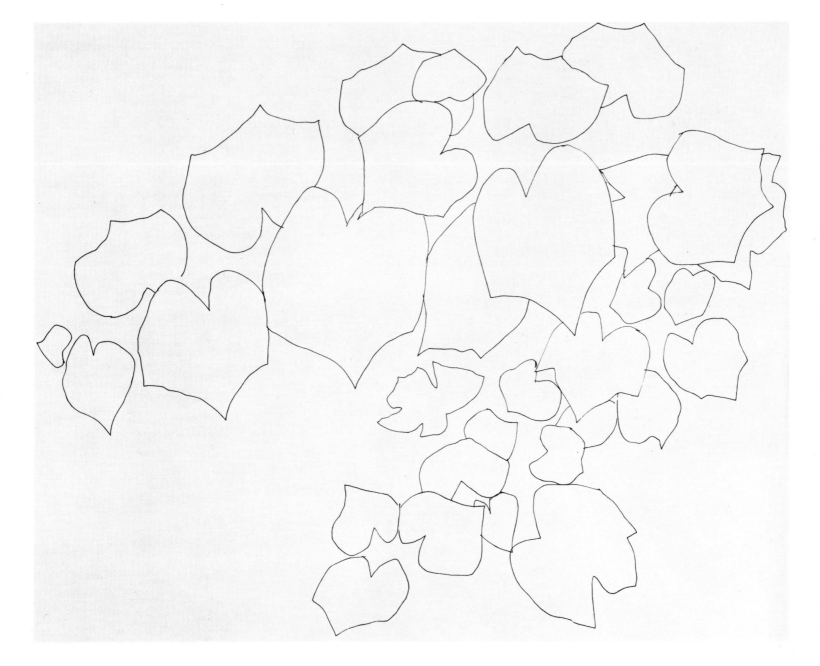

146. *Wild grape leaves,* 1961. Ink, 22⅝ × 28½ in.

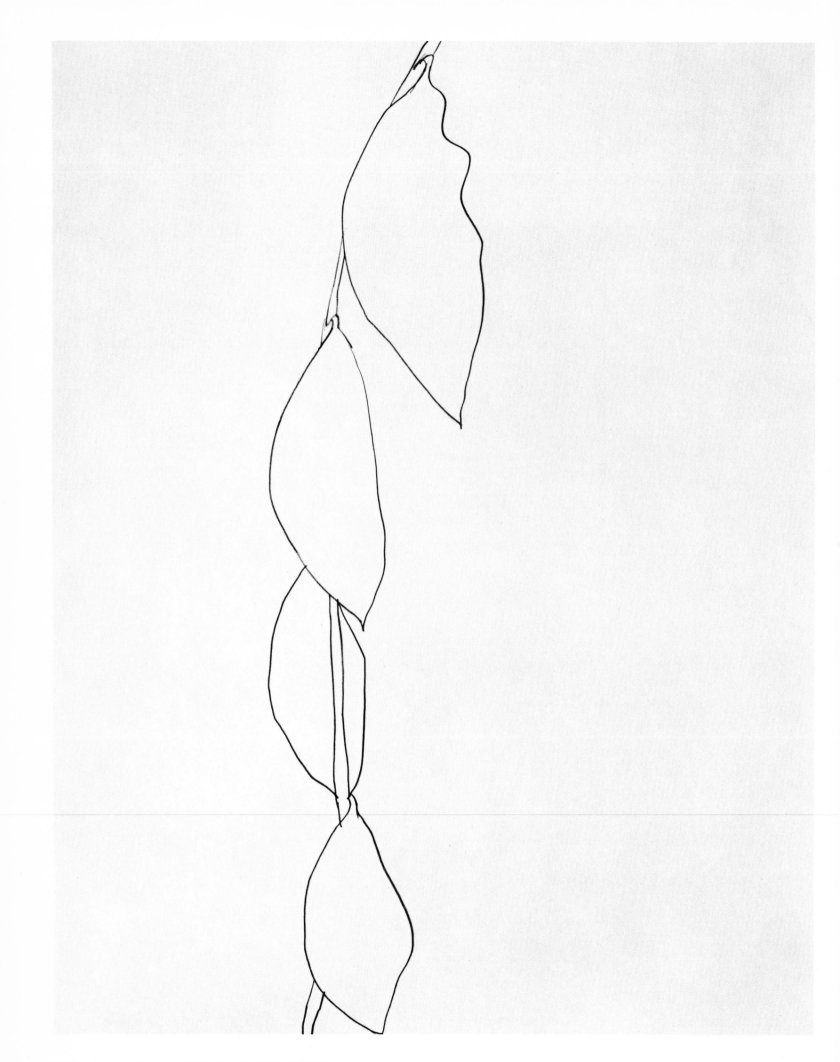

147. *Lemon branch,* 1964. Pencil, 28½ × 22½ in.

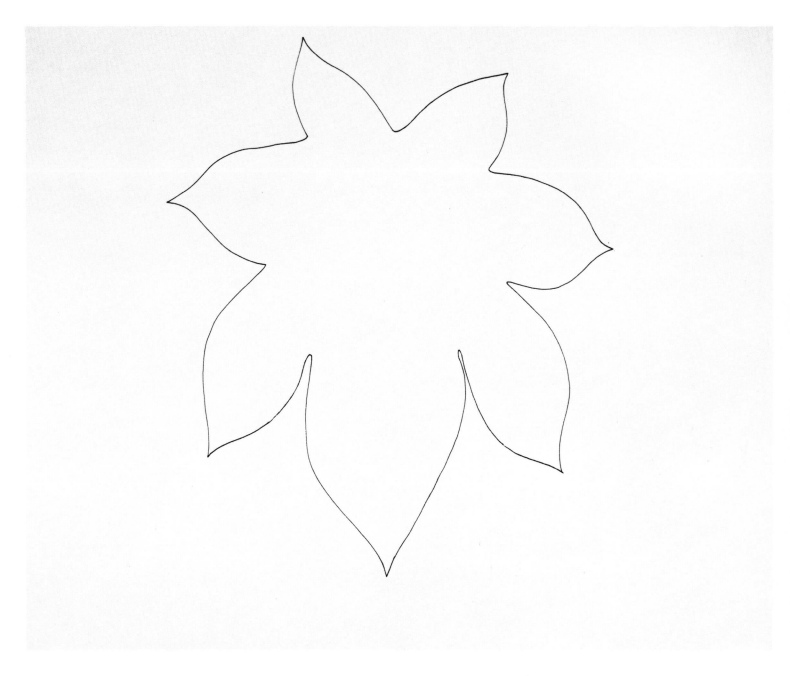

148. *Castor bean leaf,* 1961. Ink, 22⅝×28½ in.

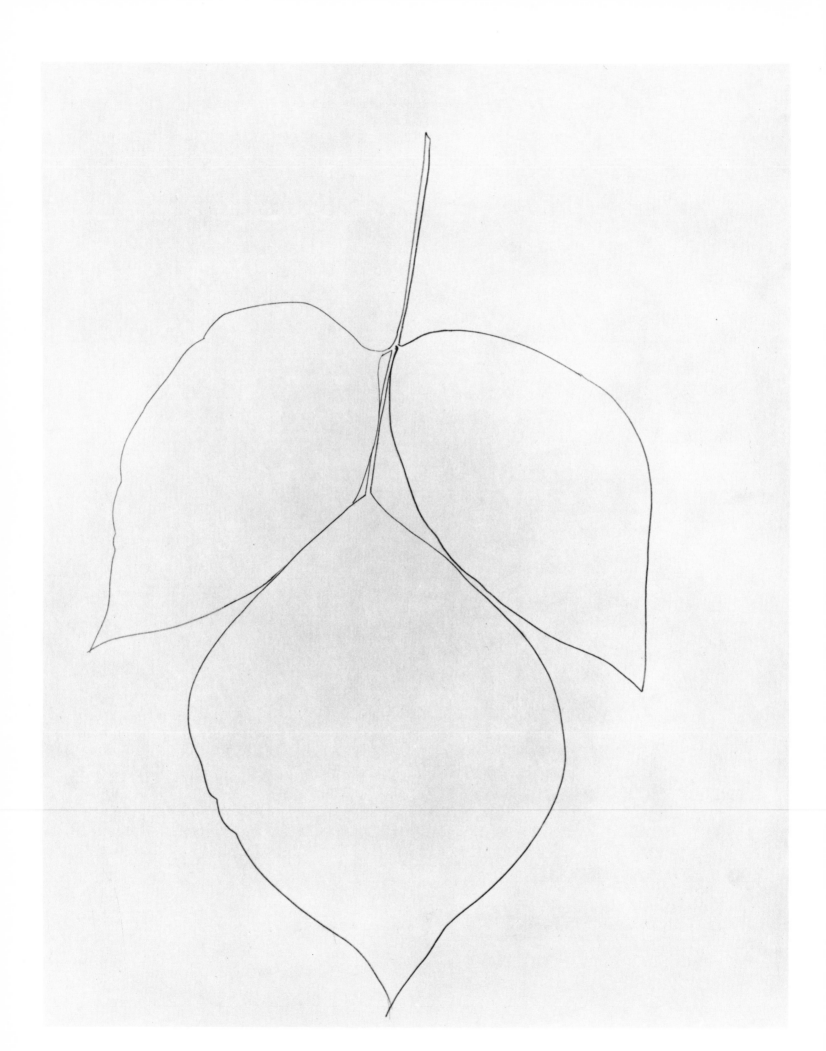

149. *Three leaves,* 1965. Pencil, 23 × 20 in.

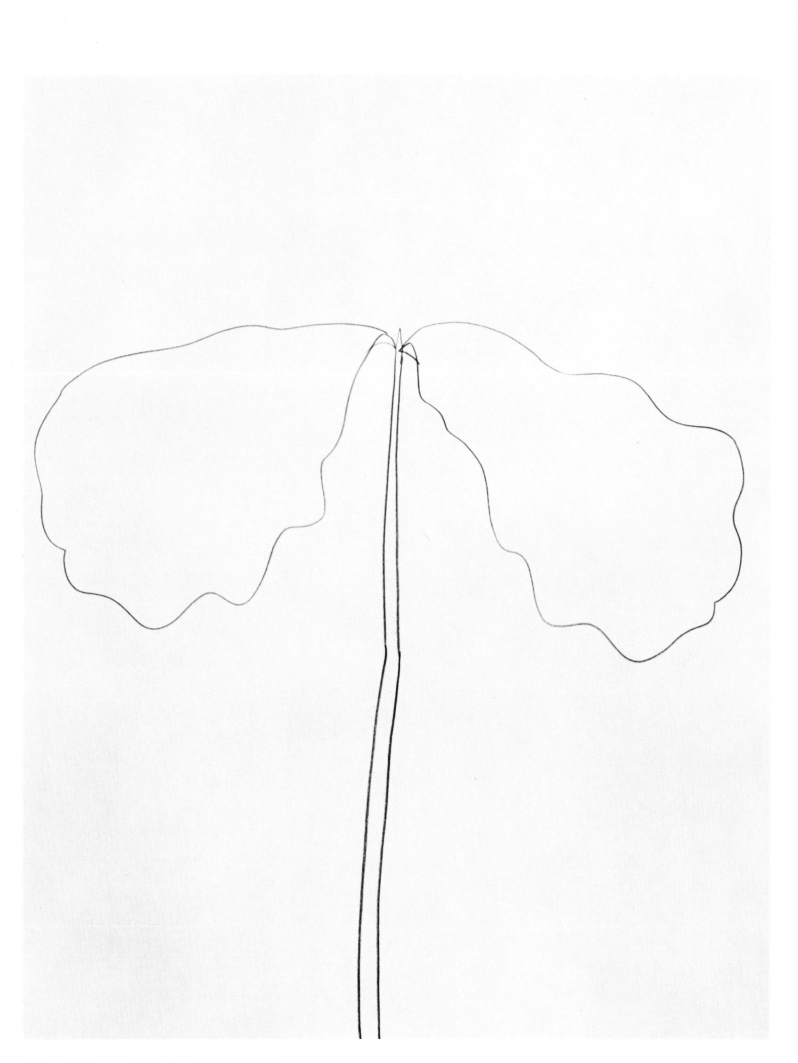

150. *Oak leaves,* 1964. Pencil, 28½ × 22⅝ in.

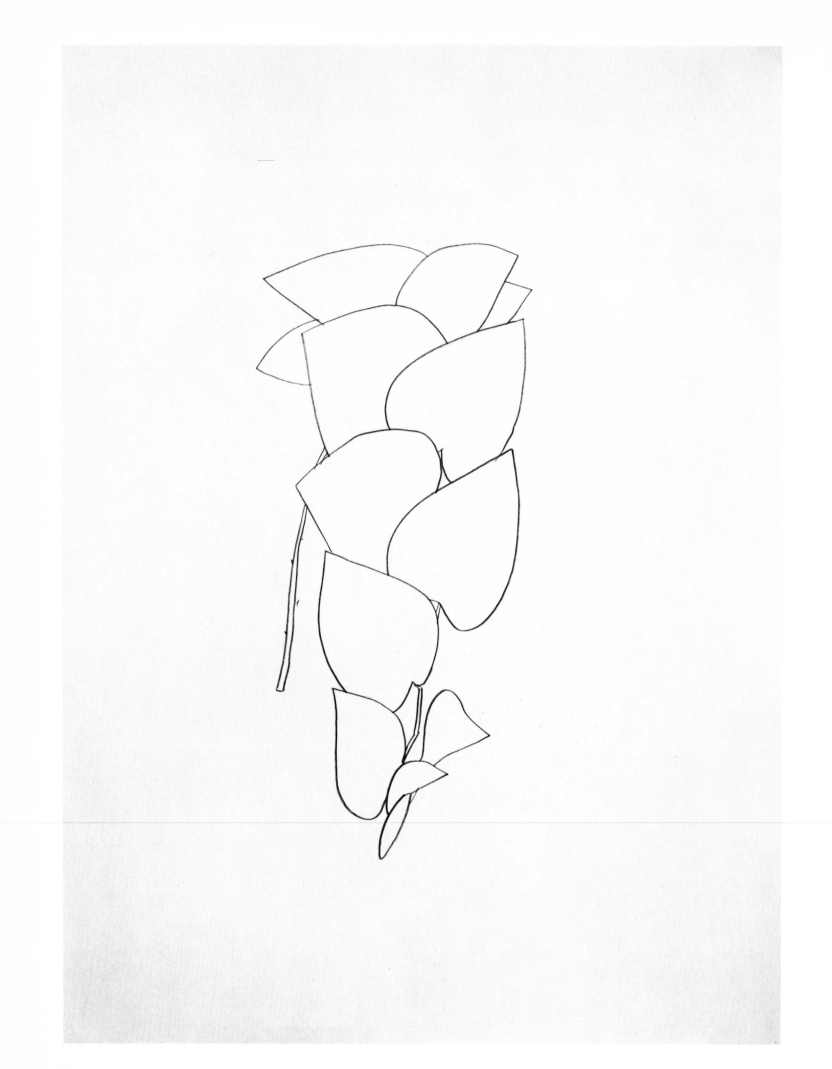

151. *Briar leaves,* 1967. Pencil, 29¾ × 22⅛ in.

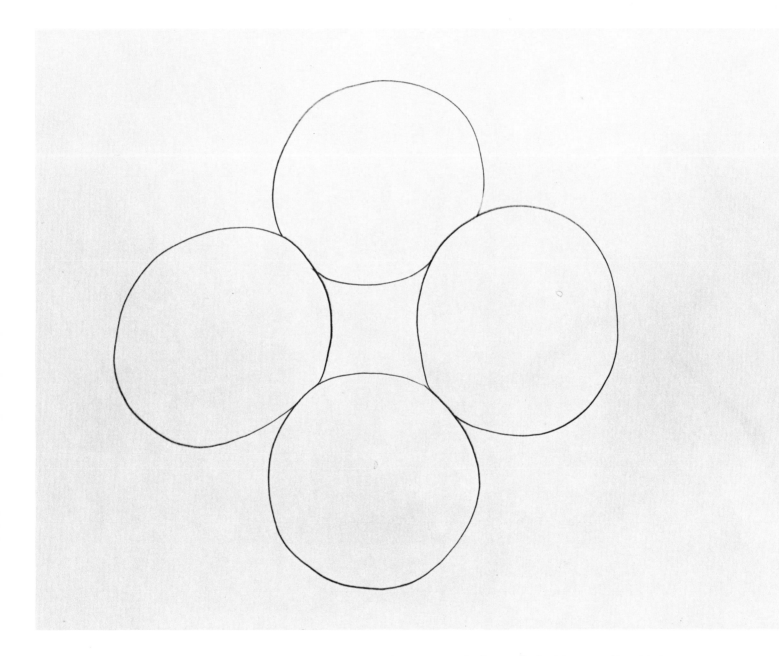

152. *Four oranges,* 1966. Pencil, 22½ × 28½ in., Collection: The Solomon R. Guggenheim Museum, New York.

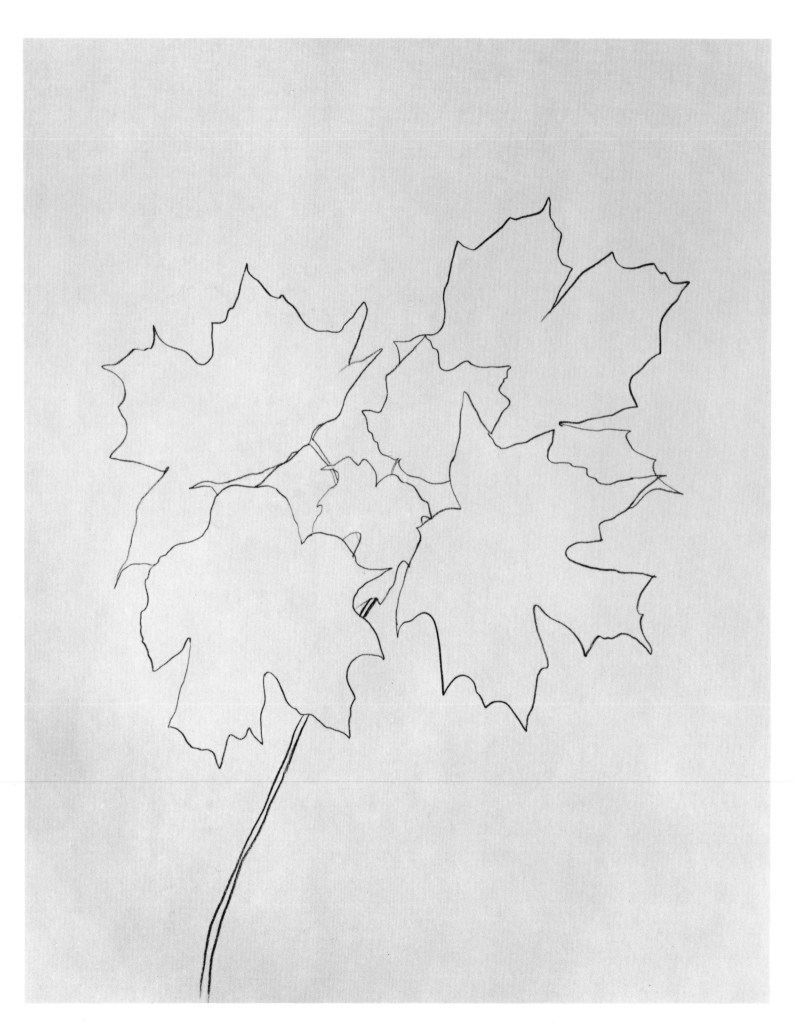

153. *Maple leaves,* 1967. Pencil, 29 × 23 in.

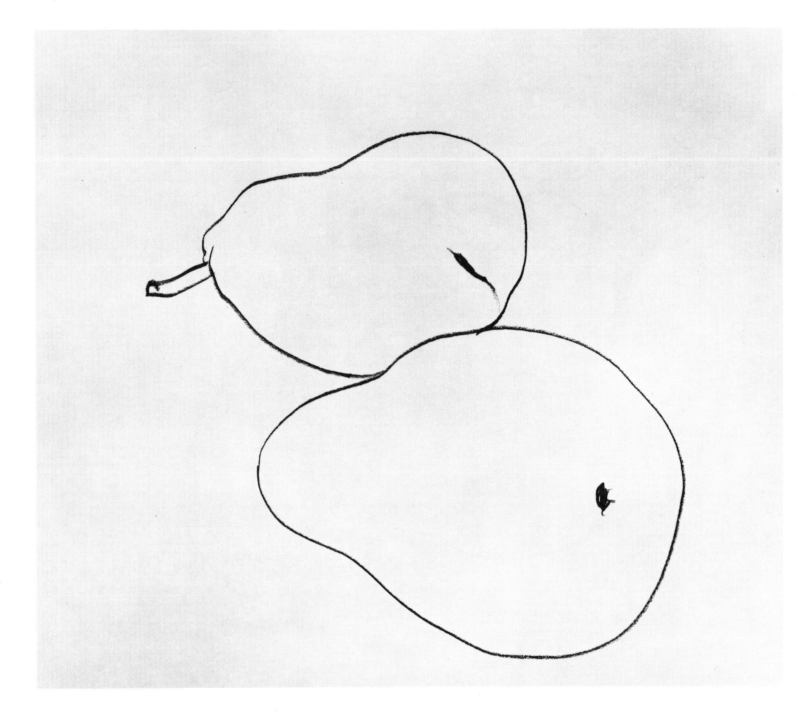

154. *Pears,* 1967. Pencil, 14 × 17 in.

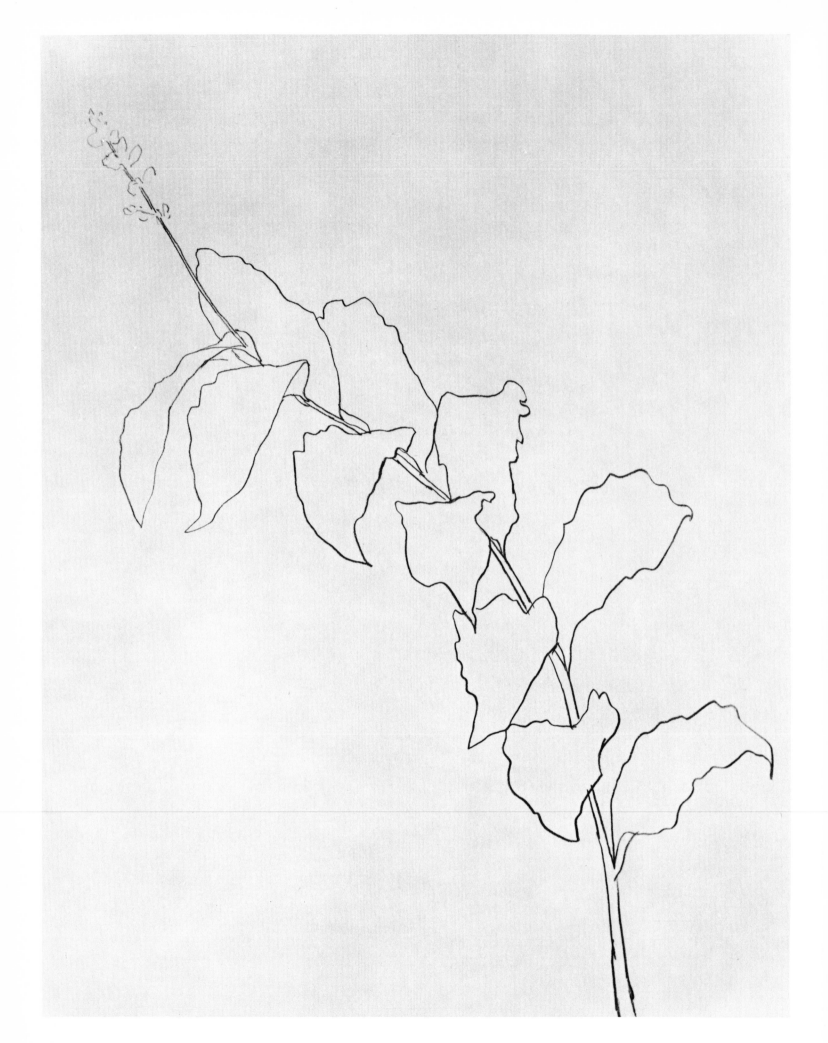

155. *Solomon's seal,* 1967. Pencil, 29 × 23 in.

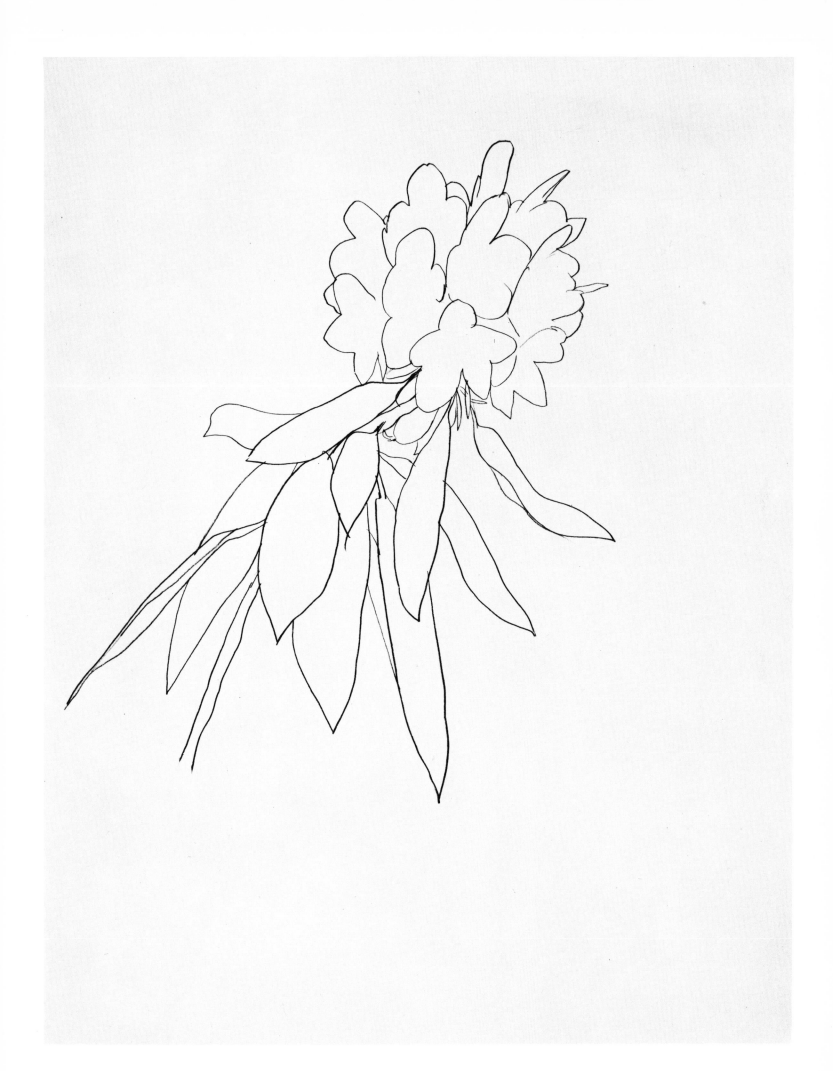

156. *Rhododendron,* 1967. Pencil, 23×20 in.

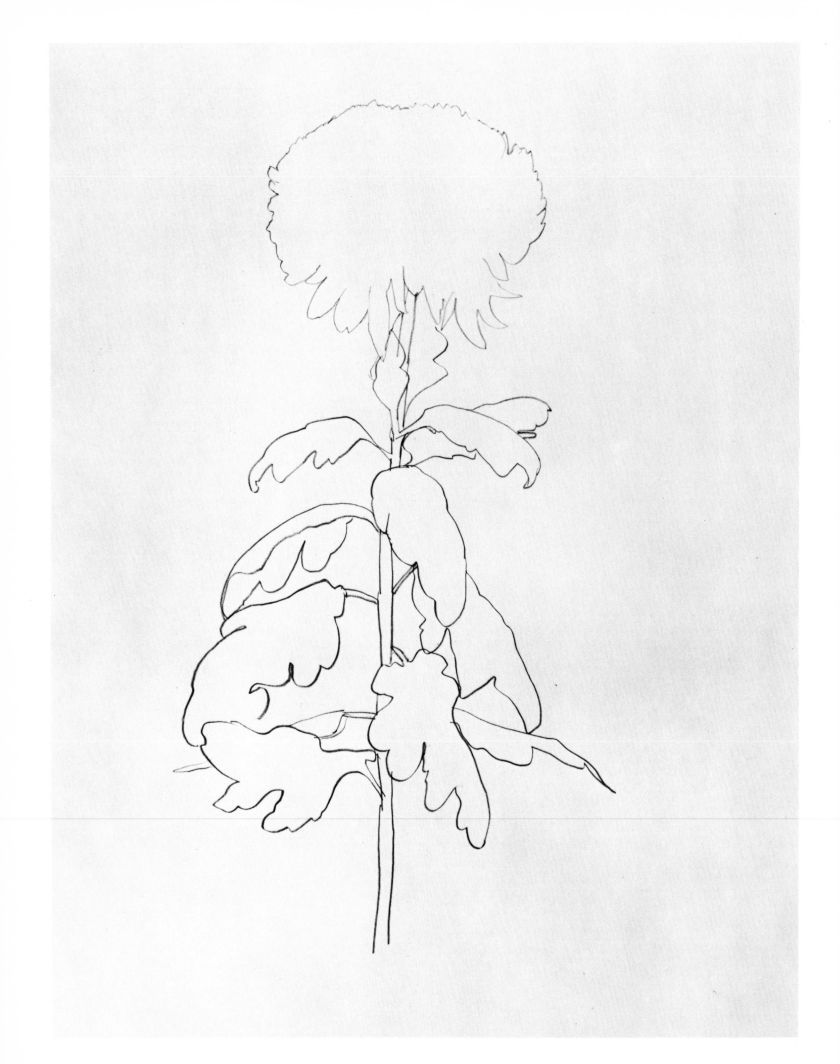

157. *Chrysanthemum,* 1967. Pencil, 29¾ × 22¼ in.

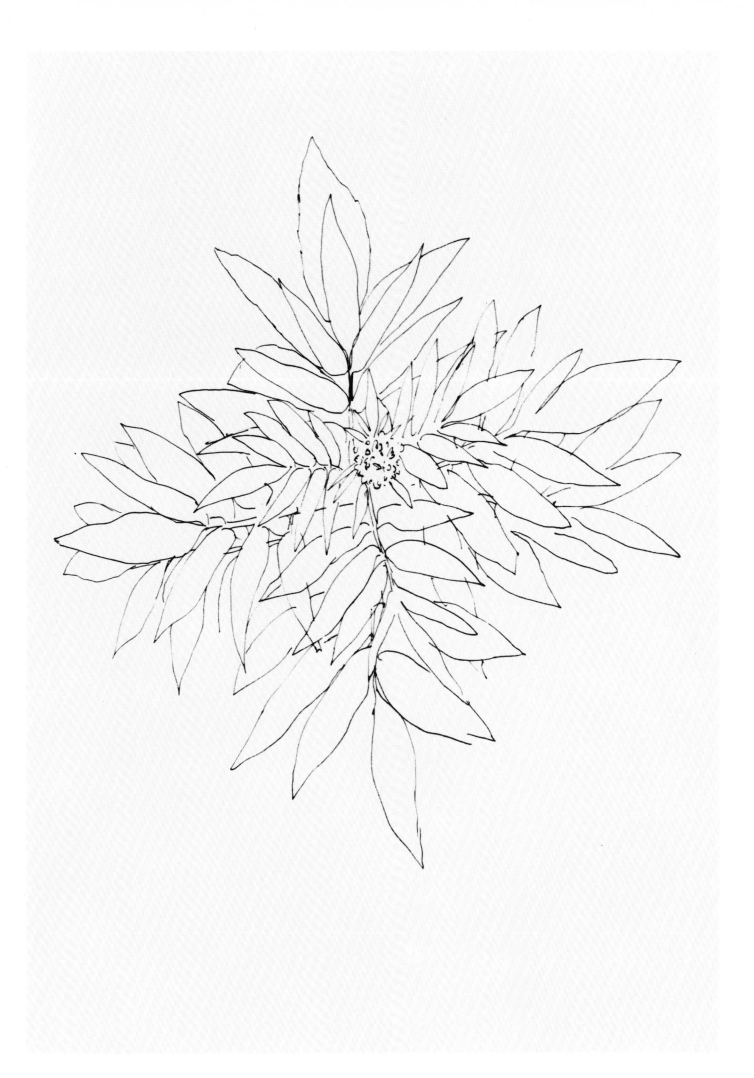

158. *Plant near Cahors,* 1965. Ink, 21 × 14½ in.

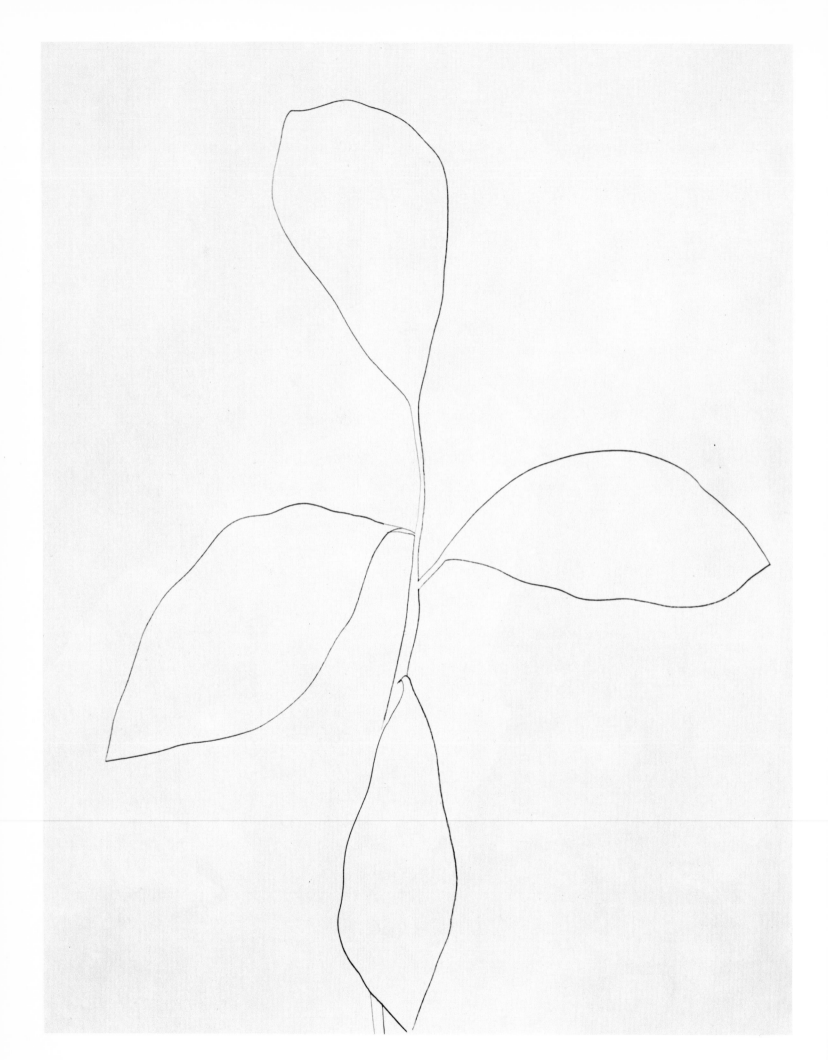

159. *Orange leaves,* 1967. Pencil, 29 × 23 in.

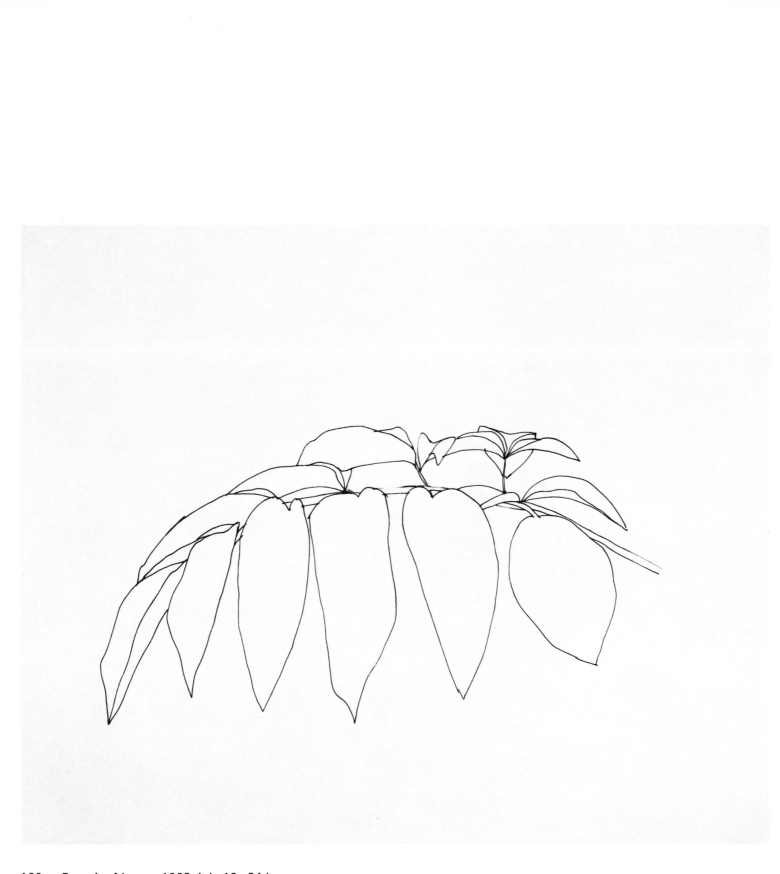

160. *Branch of leaves,* 1968. Ink, 19 × 24 in.

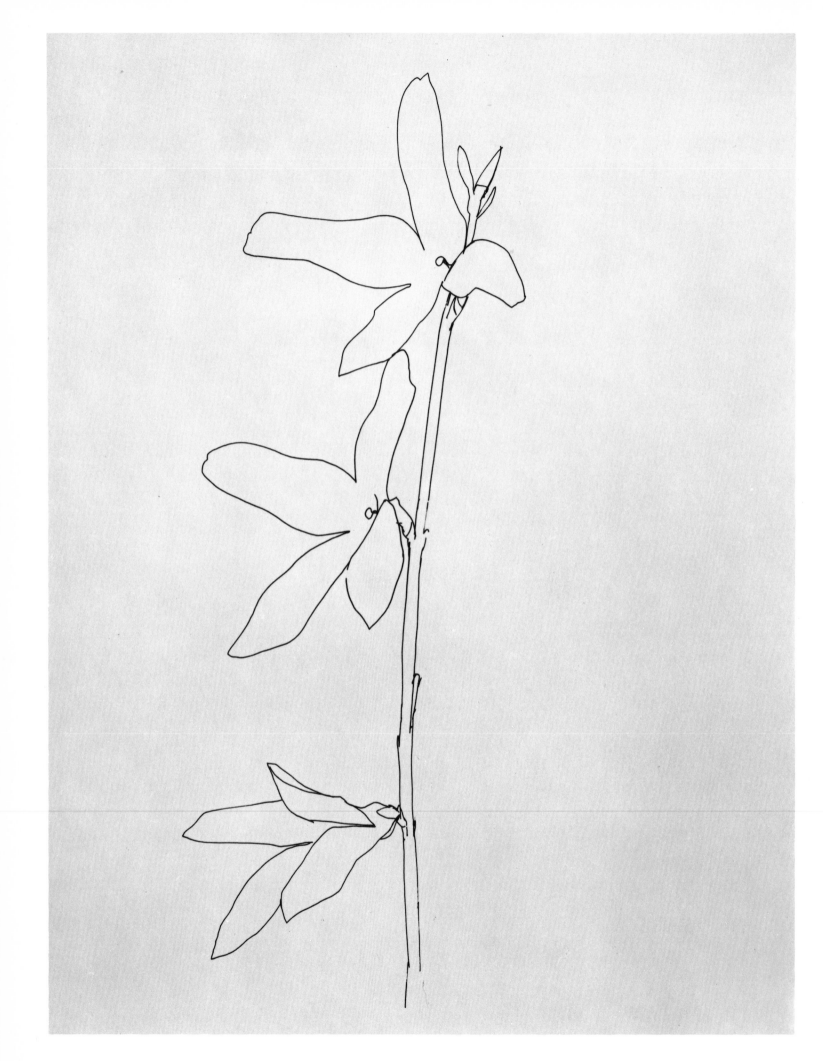

161. *Forsythia,* 1969. Ink, 29 × 23 in.

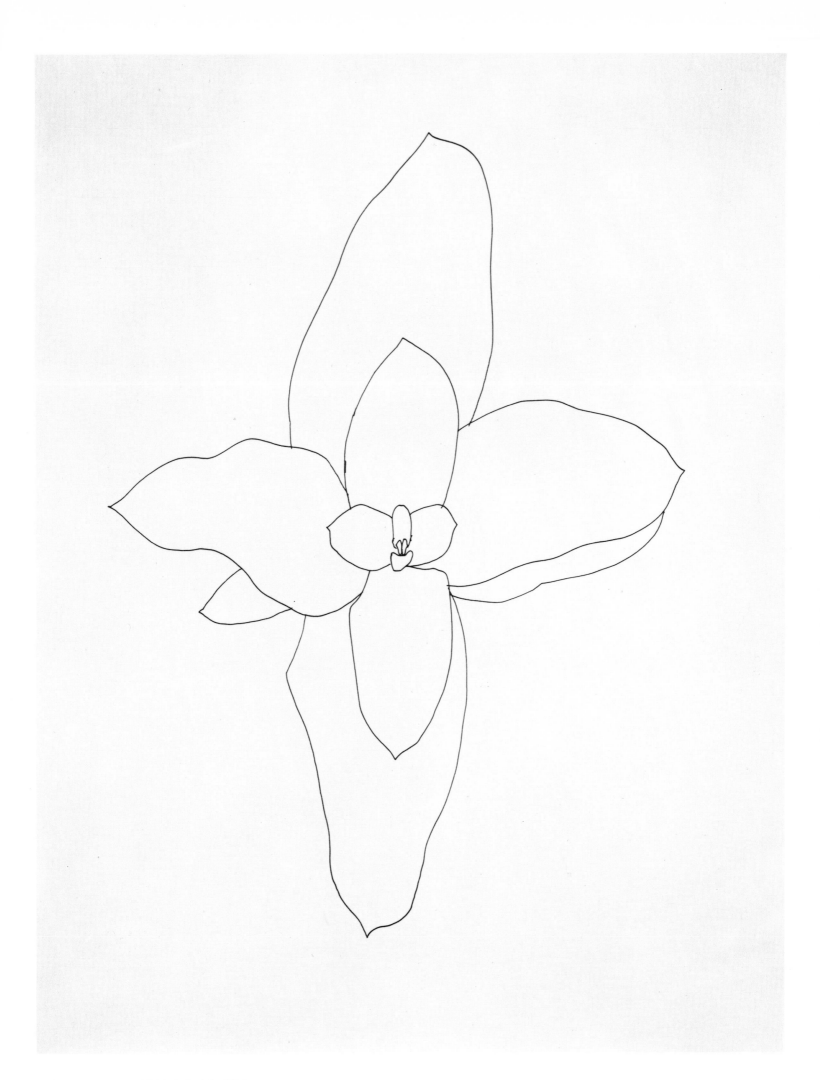

162. *Milkweed,* 1969. Ink, 29 × 23 in.

Catalogue of Prints 1950-1970

Lithographs and Silkscreens

1. *Untitled*, 1950
 Lithograph
 Printed by the artist, Paris
 Edition of 16, signed lower right, *Kelly,*
 and numbered lower left, 14 × 11 in.

2. *David,* 1964
 Lithograph
 Published and printed privately
 Edition of 20, signed lower right, *Kelly,*
 and numbered lower left, on B.F.K. Rives
 paper, 35 × 24 in.

3. *Red blue,* 1964
 Silkscreen
 Published by the Wadsworth Atheneum,
 Hartford and printed by Ives-Sillman,
 New Haven
 From *A Portfolio of 10 Works by 10 Painters*
 Edition of 500, unsigned and unnumbered,
 on Mohawk Superfine paper, 22 × 17 in.

4. *Black form,* 1967
 Lithograph
 Published and printed by Hollanders
 Workshop, Inc., New York
 From *Portfolio of 9 Artists - Lithographs*
 Edition of 100, signed lower right, *Kelly,*
 and numbered lower left, on B.F.K. Rives
 paper, 20 × 24 in.

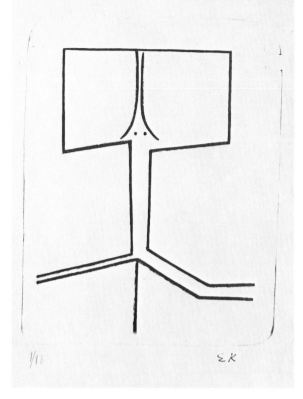

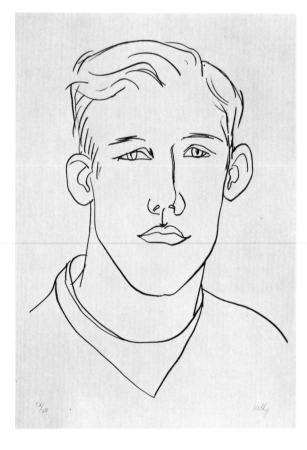

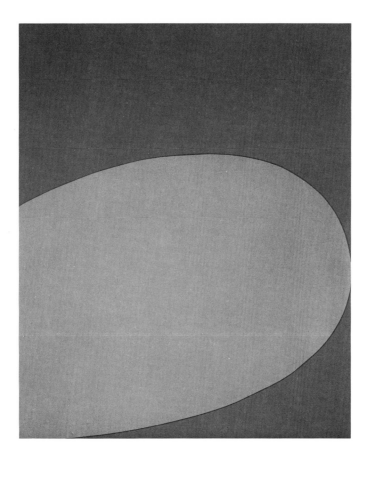

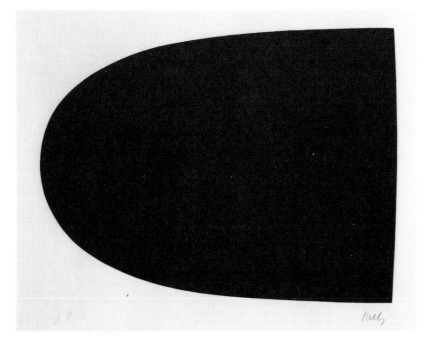

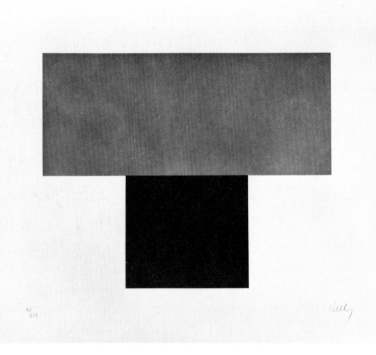

5. *Red over black,* 1970
 Silkscreen
 Published by The Solomon R. Guggenheim
 Museum, New York
 Printed by Gemini, G.E.L., Los Angeles
 Edition of 250, signed lower right, *Kelly*,
 numbered lower left, on Arjomari paper,
 25 × 30 in.

Suite of
27 color lithographs, 1964

Published and printed by Maeght
Editeur, Paris. Edition of 75, signed
lower right, *Kelly*, and numbered
lower left, on Rives B.F.K. paper.
The number in the caption in
parentheses designates the number
within the suite.

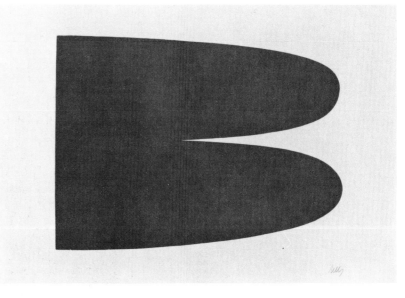

6. *Red-orange* (3)
 24 × 35 in.

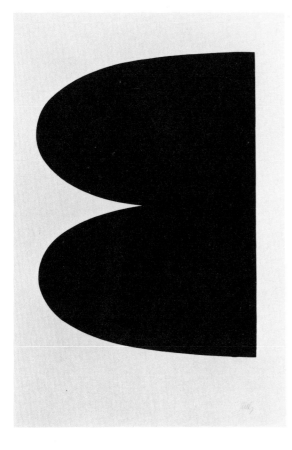

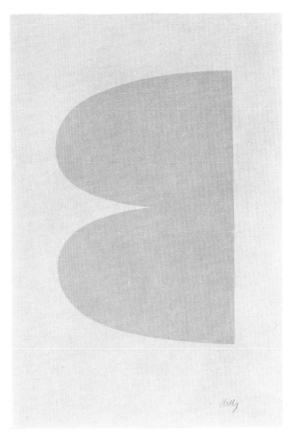

7. *Black* (1)
 35 × 24 in.

8. *Yellow* (2)
 35 × 24 in.

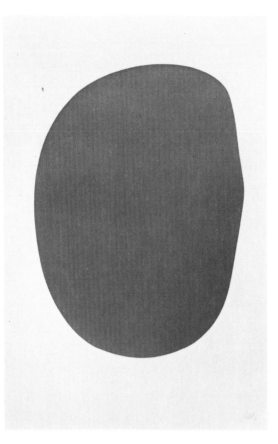

9. *Green* (4)
 35 × 24 in.

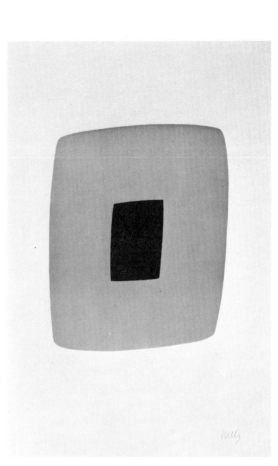

10. *Orange with blue* (9)
 35 × 24 in.

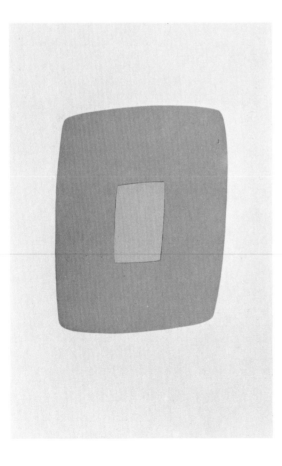

11. *Light blue with orange* (11)
 35 × 24 in.

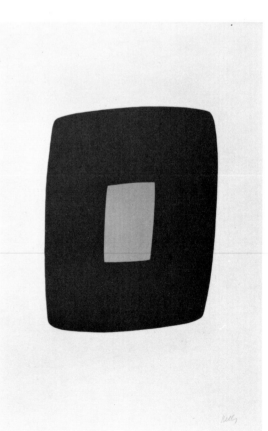

12. *Green with red* (8)
 35 × 24 in.

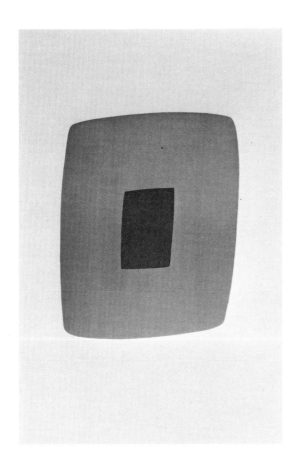

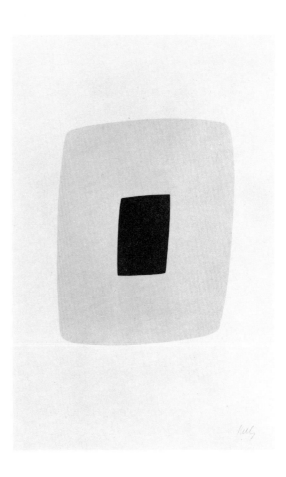

13. *Orange with green* (10)
 35 × 24 in.

14. *Yellow with dark blue* (12)
 35 × 24 in.

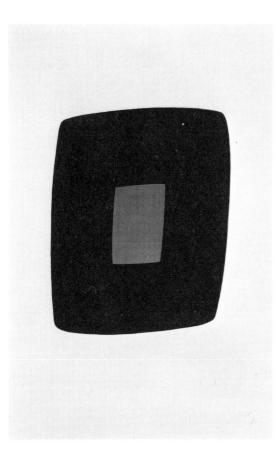

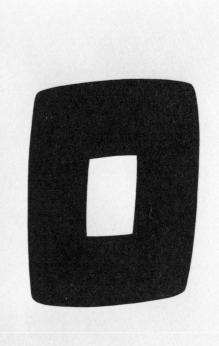

15. *Dark blue with red* (7)
 35 × 24 in.

16. *Black with white* (6)
 35 × 24 in.

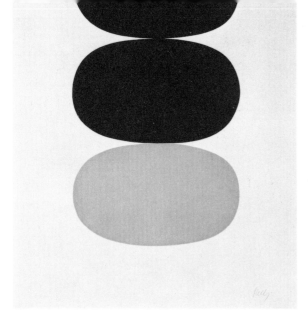

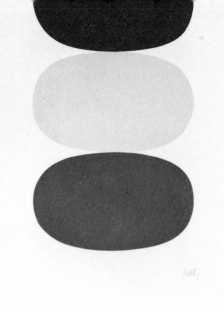

17. *Blue and orange and green* (13)
 35 × 24 in.

18. *Blue and yellow and red-orange* (14)
 35 × 24 in.

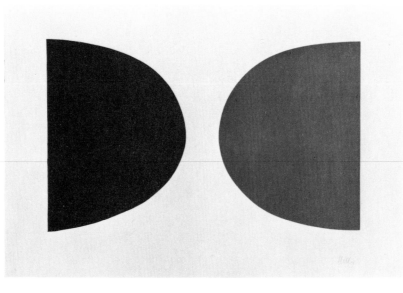

19. *Blue and orange* (5)
 24 × 35 in.

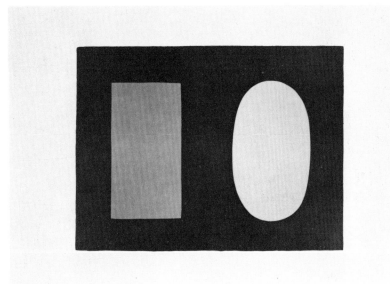

20. *Orange and blue over yellow* (27)
 24 × 35 in.

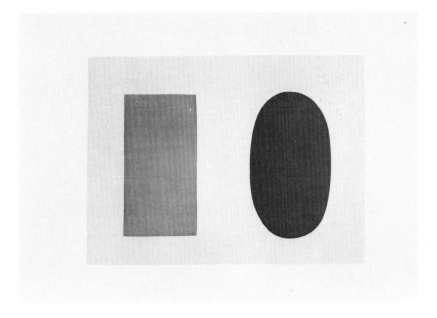

21. *Blue and green over orange* (26)
 24 × 35 in.

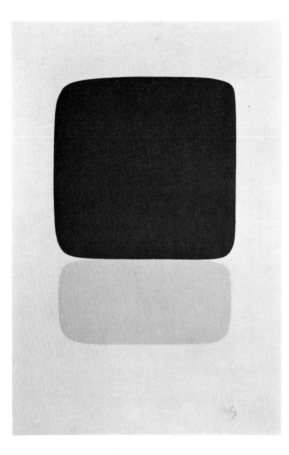

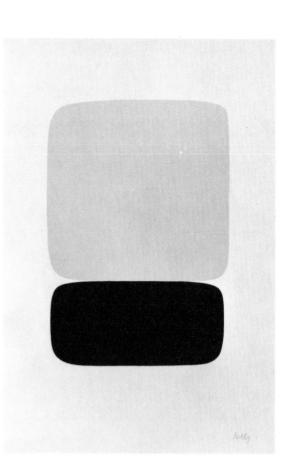

22. *Red over yellow* (16)
 35 × 24 in.

23. *Yellow over dark blue* (19)
 35 × 24 in.

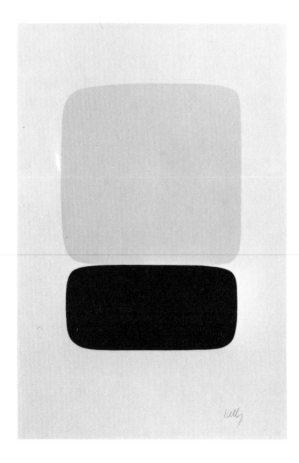

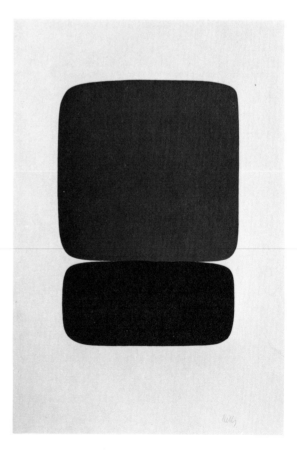

24. *Yellow over black* (20)
 35 × 24 in.

25. *Red-orange over blue* (17)
 35 × 24 in

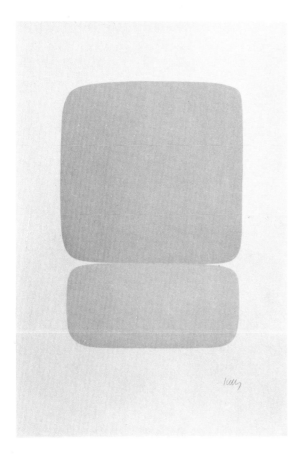

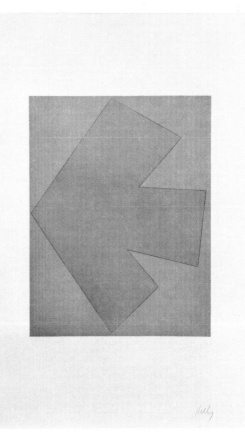

26. *Yellow over yellow* (22)
 35 × 24 in.

27. *Orange over green* (24)
 35 × 24 in.

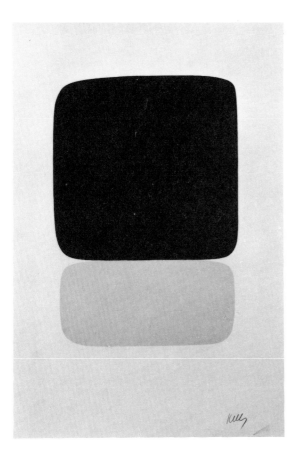
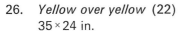

28. *Black over yellow* (21)
 35 × 24 in.

29. *Blue over orange* (18)
 35 × 24 in.

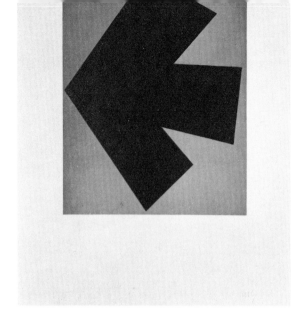

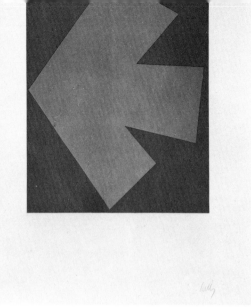

30. *Blue over green* (23)
 35 × 24 in

31. *Orange over blue* (25)
 35 × 24 in.

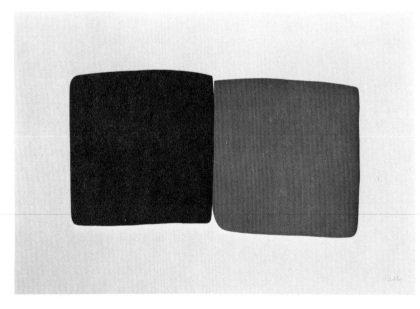

32. *Dark blue and red* (15)
 24 × 35 in.

Suite of plant lithographs, 1964-1966

Published and printed by Maeght Editeur, Paris
Edition of 75, with the exception of
Nos. 56-57, edition of 50,
signed lower right, *Kelly,* and
numbered lower left, on Rives paper
The number in parentheses in the caption
designates the number within the suite.

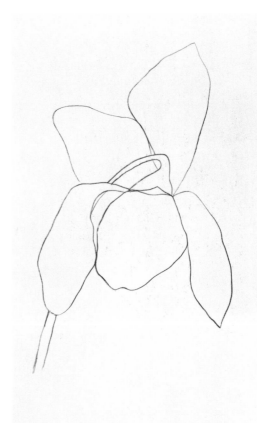

33. *Cyclamen I* (5)
35½ × 24 in.

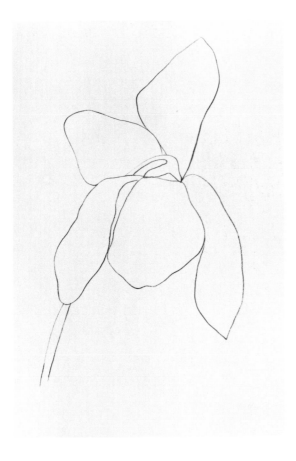

34. *Cyclamen II* (6)
35½ × 24¼

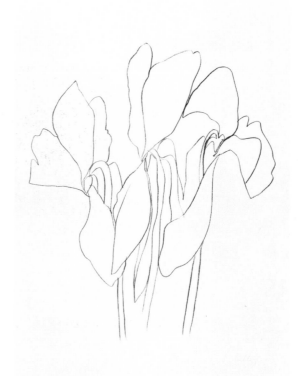

35. *Cyclamen V* (9)
35½ × 24¼ in.

36. *Cyclamen III* (7)
 35½ × 24¼ in.

37. *Cyclamen IV* (8)
 35½ × 24¼ in.

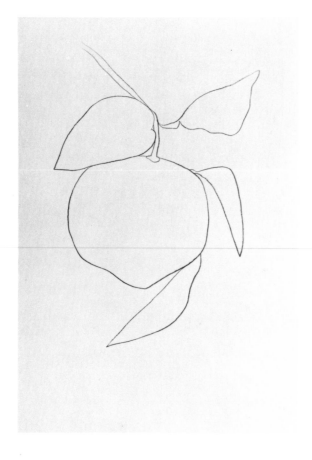

38. *Grapefruit* (2)
 35¼ × 24 in.

39. *Leaves* (1)
 35¼ × 24 in.

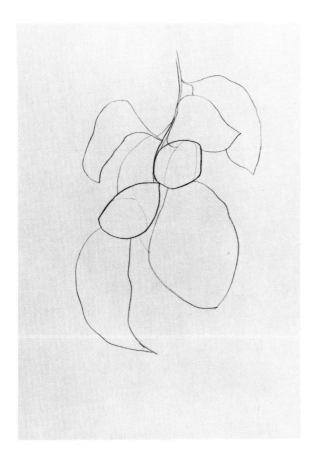

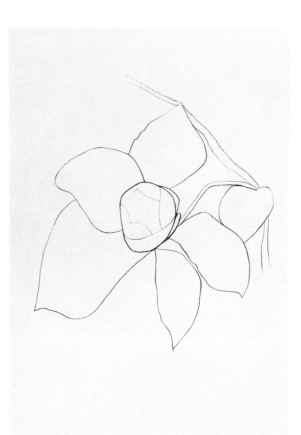

40. *Camellia III* (12)
 35½ × 24 in.

41. *Camellia II* (11)
 35⅝ × 25 in.

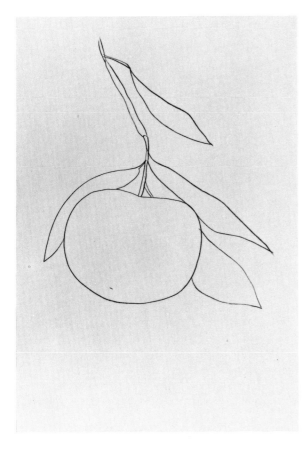

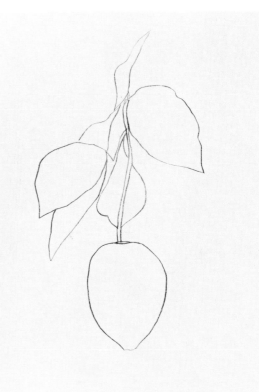

42. *Tangerine* (3)
 35¼ × 24¼ in.

43. *Lemon* (4)
 35¼ × 24¼ in.

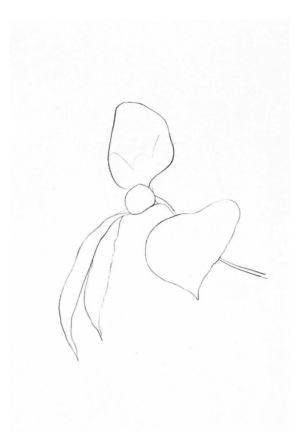

44. *Camellia I* (10)
 35¼ × 24 in.

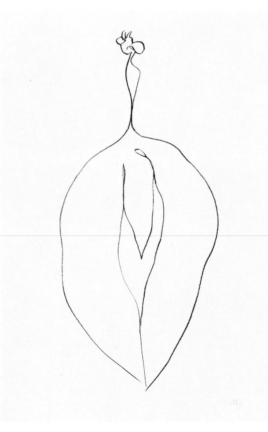

45. *Seaweed* (22)
 35½ × 24⅜ in.

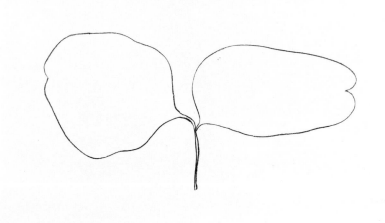

46. *Locust* (21)
24 × 35¼ in.

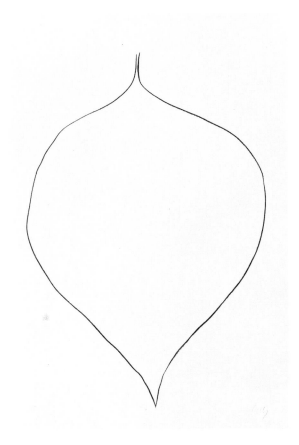

47. *Catalpa leaf* (23)
35⅝ × 24⅝ in.

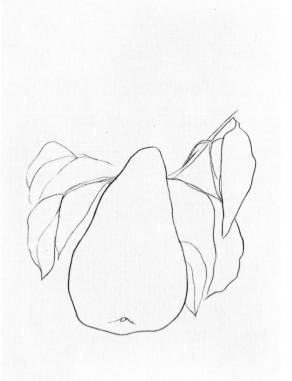

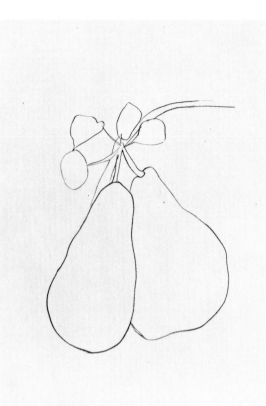

48. *Pear III* (16)
 35⅝ × 23¼ in.

49. *Pear II* (15)
 34⅝ × 23¼ in.

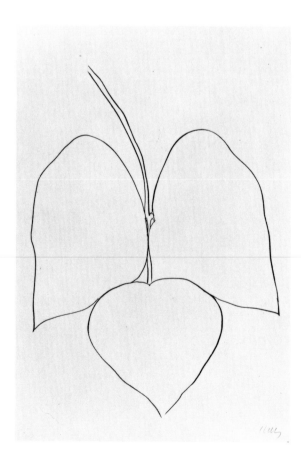

50. *String bean leaves II* (18)
 35½ × 24⅝ in.

51. *String bean leaves I* (17)
 35½ × 24⅝ in.

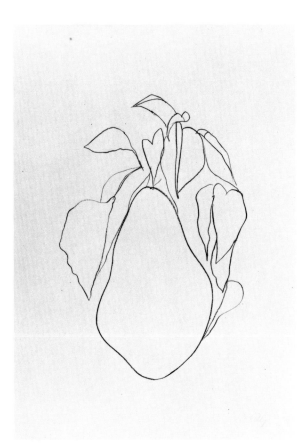

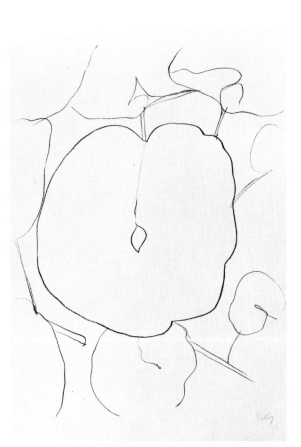

52. *Pear I* (14)
35½ × 24⅝ in.

53. *Melon leaf* (13)
35⅝ × 24⅝ in.

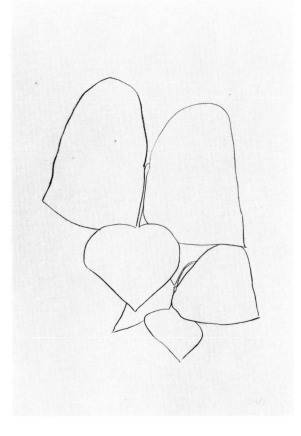

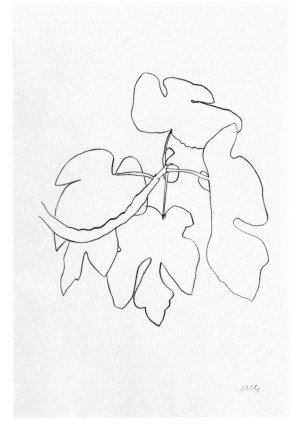

54. *String bean leaves III* (19)
35½ × 24⅝ in.

55. *Fig branch* (20)
34½ × 23⅞ in.

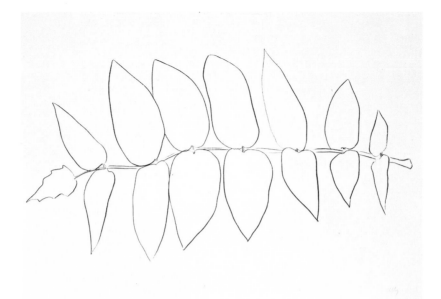

56. *Ilanthus leaves I* (27)
24⅝ × 35⅝ in.

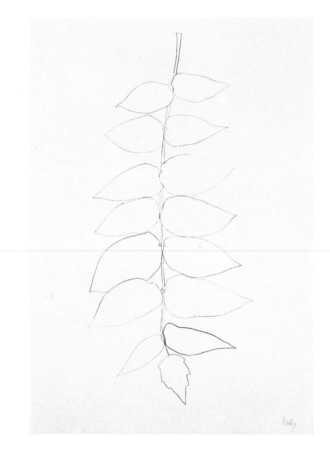

57. *Ilanthus leaves II* (28)
35⅝ × 24⅝ in.

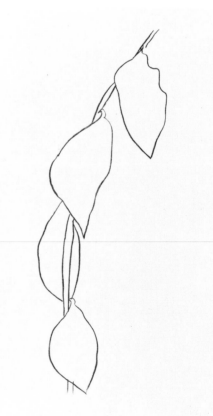

58. *Lemon branch* (26)
35½ × 24 in.

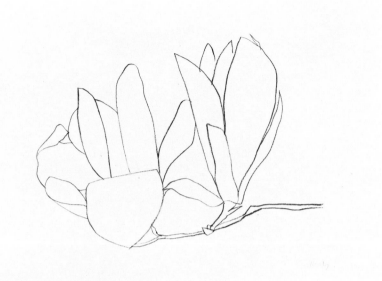

59. *Magnolia* (25)
 24⅝ × 36¾ in.

60. *Oranges* (24)
 24 × 32⅜ in.

Suite of 10 color lithographs, 1970

Published and printed by Gemini G.E.L.,
Los Angeles
Edition of 75, signed lower right, *Kelly*, and
numbered lower left, on Arjomari paper
© Gemini G.E.L. 1970
The number in the caption in parentheses
designates the number within the suite.

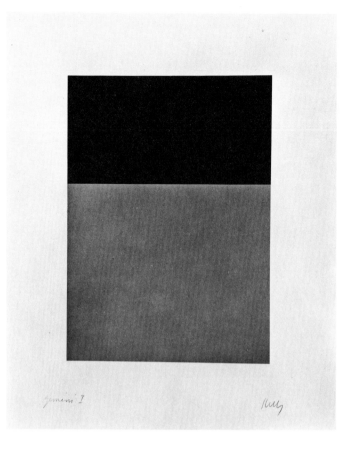

61. *Black/Green* (8)
 23¼ × 19 in.

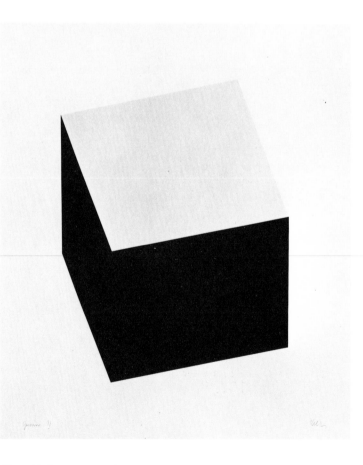

62. *Yellow/Black* (9)
 41⅜ × 36 in.

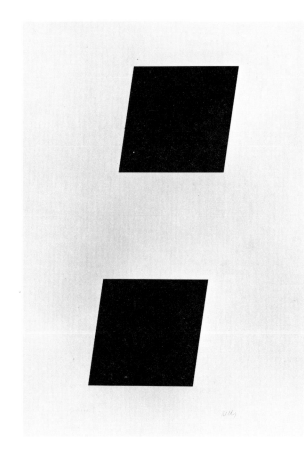

63. *Black/White/Black* (3)
42½×30 in.

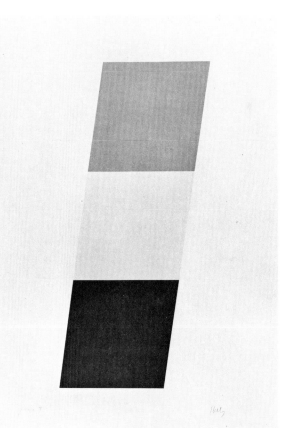

64. *Red-orange/Yellow/Blue* (2)
42½×30 in.

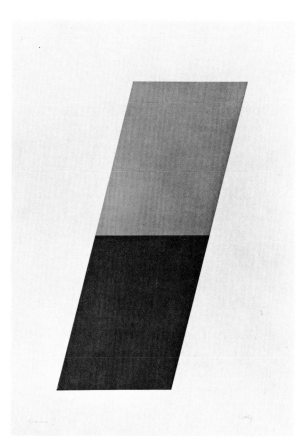

65. *Orange/Green* (4)
41½×30¼ in.

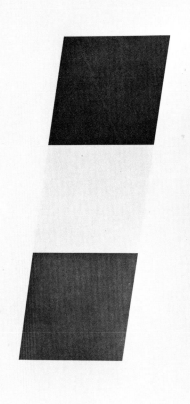

66. *Blue/Yellow/Red* (1)
42½×30 in.

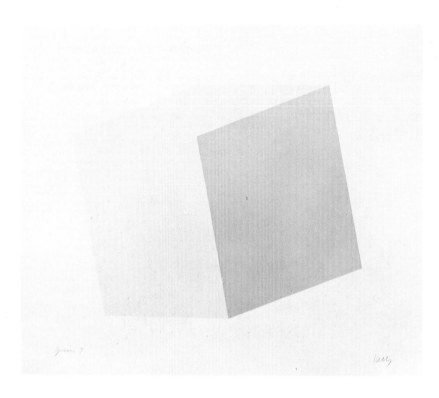

67. *Yellow/Orange* (10)
 35 × 41⅜ in.

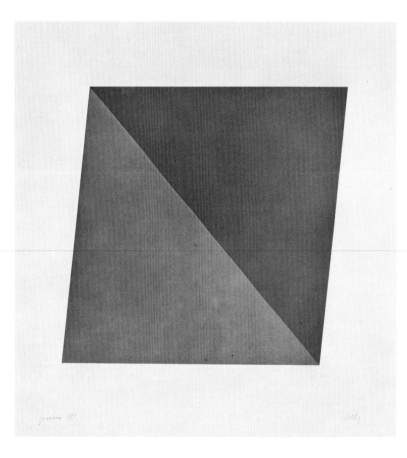

68. *Blue/Green* (5)
 30½ × 37¾ in.

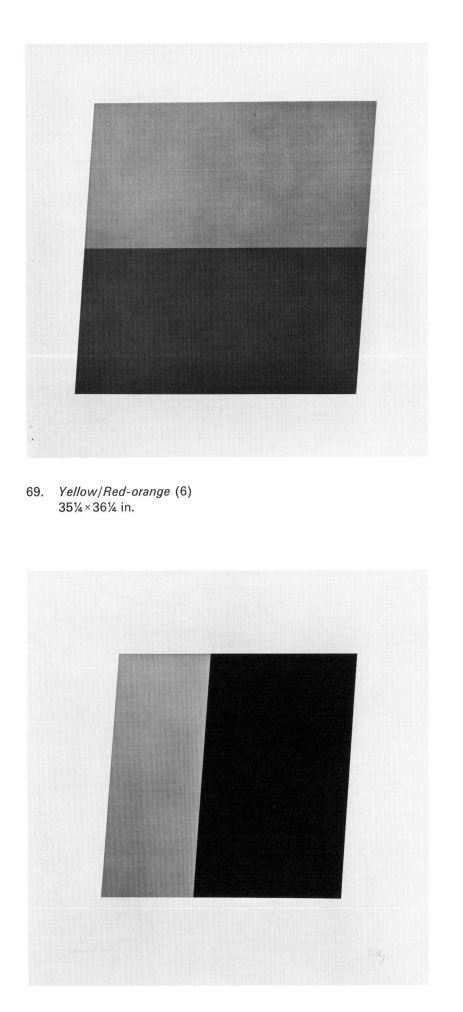

69. *Yellow/Red-orange* (6)
 35¼ × 36¼ in.

70. *Blue/Black* (7)
 36 × 34½ in.

71. *Galerie Arnaud,* 1951
 Linoleum block print in yellow and black
 Published by the artist and printed by François DiDio, Paris
 Unsigned and unnumbered edition, 21⅝ × 17½ in.

72. *Ellsworth Kelly Galerie Maeght,* 1958
 Lithograph in black and red
 Published by Maeght Editeur, Paris and printed by Imprimerie Arte, Paris
 Unsigned and unnumbered edition, 25⅝ × 19½ in.

73. *Kelly Galerie Maeght,* 1964
 Lithograph in red and green
 Published and printed by Maeght Editeur, Paris
 Unsigned and unnumbered edition, 26 × 20⅛ in.

74. *Kelly Lithographies Galerie Adrien Maeght,* 1965
 Lithograph in blue and yellow
 Published by Galerie Adrien Maeght, Paris and printed by Imprimerie Arte, Paris
 Unsigned and unnumbered edition, 26⅛ × 19¾ in.
 Edition avant la lettre of 90, signed lower right, *Kelly,* and numbered lower left, on Arches paper, 26⅛ × 19¾ in.

75. *Vivian Beaumont Theatre, Lincoln Center,* 1965
 Lithograph in red, yellow, green and blue
 Published by the Albert A. List Foundation Commission and printed by the Pratt Graphic Art Center, New York
 Edition of 100, signed lower right, *Kelly,* and numbered lower left, 46 × 30 in.

76. *Paris Review,* 1968
 Silkscreen in blue, green and red
 Published by Paris Review and printed by Chiron Press, New York
 Edition of 150, signed lower right, *Kelly,* and numbered lower left, 40 × 26⅛ in.

77. *The Art of the Real,* 1968
 Offset lithograph in blue, yellow and red
 Published by The Museum of Modern Art, New York and printed by Colorcraft, New York
 Signed in plate upper right, *Kelly,* unnumbered edition, 53¼ × 23¼ in.

78. *L'Art Vivant aux Etats-Unis,* 1970
 Offset lithograph in red and blue
 Published by Fondation Maeght and printed by Imprimerie Arte, Paris
 Unsigned and unnumbered edition, 28½ × 19¾ in.

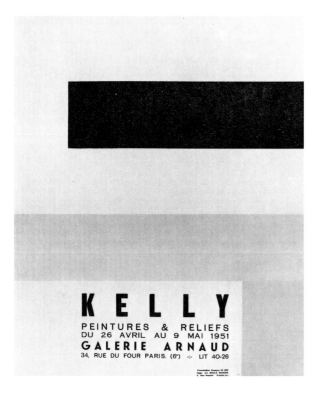

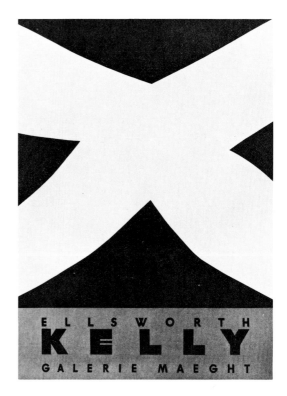

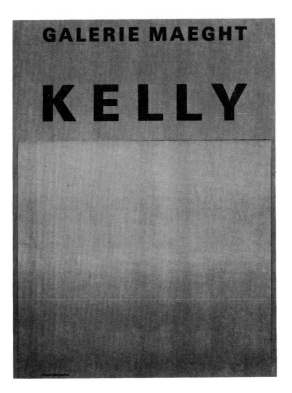

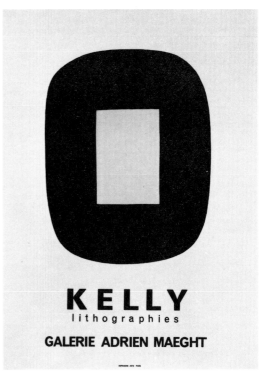

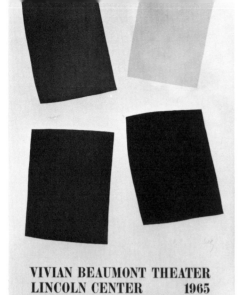

VIVIAN BEAUMONT THEATER
LINCOLN CENTER 1965

PARIS REVIEW

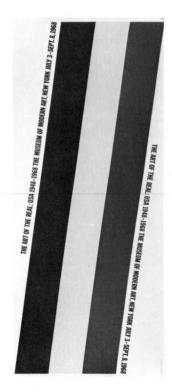

THE ART OF THE REAL: USA 1948-1968 THE MUSEUM OF MODERN ART, NEW YORK JULY 3 - SEPT. 8, 1968

THE ART OF THE REAL: USA 1948-1968 THE MUSEUM OF MODERN ART, NEW YORK JULY 3 - SEPT. 8, 1968

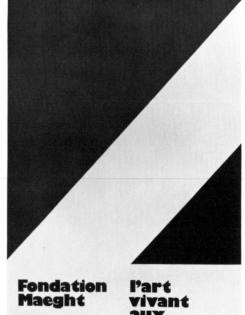

Fondation
Maeght

06 Saint-Paul

l'art
vivant
aux
Etats-Unis

18 juillet - 30 septembre 1970

Biography and Bibliography

Biography

Born in Newburgh, New York, May 31, 1923
Studied art at Pratt Institute, Brooklyn, 1941-42
Served in United States Army in Europe, 1943-45
Studied at Boston Museum School, 1946-48
Lives in France, 1948-54
Returns to the U.S., lives in New York City, 1954

One-man Exhibitions

Galerie Arnaud, Paris, 1951
Betty Parsons Gallery, New York, 1956
Betty Parsons Gallery, New York, 1957
Galerie Maeght, Paris, 1958
Betty Parsons Gallery, New York, 1959
Betty Parsons Gallery, New York, 1961
Arthur Tooth Gallery, London, 1962
Betty Parsons Gallery, New York, 1963
Washington Gallery of Modern Art, Washington, D.C., 1963
Institute of Contemporary Art, Boston, 1964
Galerie Maeght, Paris, 1964
Ferus Gallery, Los Angeles, 1965
Sidney Janis Gallery, New York, 1965
Galerie Adrien Maeght, Paris, 1965
Galerie Ricke, Kassel, 1965
Ferus Gallery, Los Angeles, 1966
Sidney Janis Gallery, New York, 1967
Irving Blum Gallery, Los Angeles, 1967
Sidney Janis Gallery, New York, 1968
Irving Blum Gallery, Los Angeles, 1968

Selected Books

Arnason, H. H. *History of Modern Art: Painting, Sculpture, Architecture*. 1968. New York, Harry N. Abrams, Inc., ill. ["Art Since Mid-Century", p. 521, bibliography].

Ashton, Doré. *A Reading of Modern Art*. 1969. Cleveland, The Press of Case Western Reserve University.

Battcock, Gregory (Ed.). *Minimal Art: A Critical Anthology*. 1968. New York, E. P. Dutton & Co., Inc., ill.

Cummings, Paul. *Dictionary of Contemporary American Artists*. 1966. Toronto, The Macmillan Co. of Canada Ltd., pp. 164-165, ill.

Geldzahler, Henry. *American Painting in the 20th Century*. 1965. New York, The Metropolitan Museum of Art, pp. 151-152, ill.

—*New Art Around the World: Painting & Sculpture*. 1966. New York, Harry N. Abrams, Inc. ill. ["United States" by Sam Hunter pp. 9-58].

Rickey, George. *Constructivism: Origins and Evolution*, 1967. New York, George Braziller., pp. 131, 160, ill. [Selected bibliography by Bernard Karpel].

Rose, Barbara. *American Art Since 1900 - A Critical History*. 1967. New York, Frederick A. Praeger, pp. 229-231, ill.

—*American Painting: The Twentieth Century*. 1964. Cleveland, The World Publishing Company, Skira Editions, ill. ["The Sixties", pp. 89-116].

Selected Periodicals

Alloway, Lawrence. "Heraldry and Sculpture". *Art International* Vol. VI, No. 3, April 1962, pp. 52-53, ill.

—"London Letter: Classicism or Hard Edge?". *Art International* Vol. IV, No. 2-3, 1960, pp. 60-61, ill.

—"On the Edge". *Architectural Design* XXX, April 1960. pp. 164-165, ill.

Alvard, Julien. "Quelques Jeunes Américains de Paris". *Art d'Aujourd hui* Vol. 2, No. 6, June 1951, pp. 24-25, ill. [In French].

Ashton, Doré. "Kelly's Unique Spatial Experiences". *Studio International* Vol. 170, July 1965, pp. 40-42, ill.

—"New York Commentary: Ellsworth Kelly at Sidney Janis". *Studio International* Vol. 173, May 1967, pp. 263-264.

Coplans, John. "Post Painterly Abstraction: The Long-Awaited Greenberg Exhibition Fails to Make its Point". *Artforum* Vol. II, No. 12, Summer 1964, pp. 4-9, ill.

—"The Earlier Work of Ellsworth Kelly". *Artforum* Vol. VII, No. 10, Summer 1969, pp. 48-55, ill.

Donson, Jerome A. "The American Vanguard Exhibitions in Europe". *Art Journal* Vol. XXII, No. 4, Summer 1963, pp. 242-245.

"Four Drawings: Ellsworth Kelly". *Artforum* Vol. IV, No. 6, February 1966, pp. 40-41, ill. [No text].

Geldzahler, Henry. "Frankenthaler, Kelly, Lichtenstein, Olitski: A Preview of the American Selection at the 1966 Venice Biennale". *Artforum,* Vol. IV, No. 10, June 1966, pp. 32-38, ill. [Revised catalogue essay].

—"Interview with Ellsworth Kelly". *Art International* Vol. VIII, No. 1, February 1964, pp. 47-48, ill. [Reprinted from catalogue].

Hess, Thomas, B. "Phony Crisis in American Art". *Art News* Vol. 62, Summer 1963, pp. 24-28; 59-60, ill.

Janis, Sidney. "Correspondance: Le Grand Jeu de la Biennale". *L'Œil* Vol. 155, November 1967, p. 64 [In French].

Jurgen-Fischer, Klaus. "Neue Abstraktion". *Das Kunstwerk* Vol. XVIII, No. 10-12, April/June 1965, pp. 3-6, ill.

Lippard, Lucy. "New York Letter: Recent Sculpture as Escape". *Art International* Vol. X, No. 2, February 1966, pp. 48-58, ill.

Livingston, Jane. "Los Angeles: Ellsworth Kelly at Irving Blum". *Artforum* Vol. VI, No. 5, January 1968, pp. 60-61.

Mandelbaum, Ellen. "Isolable Units, Unity and Difficulty". *Art Journal* Vol. 27, No. 3, Spring 1968, pp. 256; 261; 270, ill.

Menna, Filiberto. "Ellsworth Kelly". *Marcatrè* Vol. 26-29, December 1966/March 1967, p. 159, ill. [In Italian].

"Penn Center Transportation Building and Concourse". *Architectural Record* Vol. 121, No. 5, May 1957, pp. 190-196, ill [cover].

Reichardt, J [asia]. "Les Expositions à l'Etranger: Londres". *Aujourd'hui* Vol. 6, September 1962, pp. 58-59 [In French].

Rose, Barbara. "The Sculpture of Ellsworth Kelly". *Artforum* Vol. V, No. 10, June 1967, pp. 51-55, ill.

—"Formalists' at the Washington Gallery of Modern Art". *Art International* Vol. VII, No. 7 September 1963, pp. 42-43, ill.

— "The Problem of Scale in Sculpture". *Art in America* Vol. 56, No. 4, July/August 1968, pp. 80-91, ill.

Rubin, William. "Ellsworth Kelly: The Big Form". *Art News* Vol. 62, November 1963, pp. 32-35; 64-65, ill.

— "Younger American Painters". *Art International* Vol. IV, No. 1, 1960, pp. 24-31, ill.

Tillim, Sidney. "Ellsworth Kelly". *Arts Yearbook 3 - Paris/New York*, 1959, pp. 148-151, ill. [Photograph of the artist].

T[yler], P[arker]. "Ellsworth Kelly". *Art News* Vol. 55, June 1956, p. 51.

Waldman, Diane. "Kelly Color". *Art News* Vol. 67, October 1968, pp. 40-41; 62-64, ill.

Selected Exhibition Catalogues

Amsterdam, Stedelijk Museum. *Vormen van de Kleur*. November 20, 1966 - January 15, 1967, ill. [Dutch text].

Basel, Kunsthalle. *Signal Exhibition: Held, Kelly, Mattmuller, Noland, Olitski, Pfahler, Plumb, Turnbull*. June 26 - September 5, 1965, ill. [German text].

Brussels, World's Fair. *American Art: Four Exhibitions*. April 17 - October 18, 1958, ill. [English, French, Dutch texts; exhibition organized by the American Federation of Arts].

Buffalo, Albright-knox Art Gallery. *Plus by Minus: Today's Half-Century*. March 3 - April 14, 1968, ill. [Text by Douglas Mac Agy].

Chicago, Art Institute of Chicago. *65th American Exhibition: Some Directions in Contemporary Painting and Sculpture*. January 5 - February 18, 1962, ill.

— *68th American Exhibition*. August 19 - October 16, 1966, ill.

Cologne, Wallraf-Richartz Museum. *Kunst der Sechziger Jahre Sammlung Ludwig*. 1969, ill. [German/English texts].

Frankfurt, Frankfurter Kunstverein. *Kompass III, New York (Paintings After 1945 in New York)*. December 20, 1967 - February 11, 1968, ill. [English/German texts by J. Leering, P. Wember, E. Rathke].

Kassel, Museum Fridericianum. *Documenta III: Internationale Ausstellung Malerei und Skulptur*. June 27 - October 5, 1964, ill. [German texts by Werner Haftmann & Arnold Bode].

— *Documenta IV: International Exhibition*. June 27 - October 6, 1968, ill. [German texts by Arnold Bode, Max Lindahl, J. Leering].

London, Camden Arts Centre. *Transatlantic Graphics 1960/67*. November 6 - December 16, 1967. [Announcement only, exhibition by Gene Baro].

London, Marlborough Fine Art Ltd. *New New York Scene*. October-November, 1961, ill. [Catalogue without text].

London, The Redfern Gallery. *Gravures Maeght Editeur*. November 29, 1966 - January 7, 1967, ill. [Essay by John Russell].

London, Tate Gallery. *Painting and Sculpture of a Decade 54/65*. April 22 - June 28, 1964, ill. [Exhibition by the Calouste Gulbenkian Foundation].

London, Arthur Tooth & Sons. *Ellsworth Kelly*. May 29 - June 23, 1962, ill. [Introduction by Lawrence Alloway; list architectural commissions].

Los Angeles, Los Angeles County Art Museum. *American Sculpture of the Sixties*. April 28 - June 25, 1967, ill. [Introduction by M. Tuchman, with critical essays & extensive bibliography].

— *Post Painterly Abstraction*. April 23 - June 7, 1965, ill. [Exhibition and text by Clement Greenberg].

Minneapolis, Dayton's Auditorium. *14 Sculptors: The Industrial Edge*. May 29 - June 21, 1969, ill. [Exhibition organized by the Walker Art Center, with texts by B. Rose, C. Finch, M. Friedman, bibliography].

Montreal, The United States Pavilion, Expo '67. *American Painting Now*. April 28 - October 27, 1967, ill. [Traveled to Horticultural Hall, Boston, with separate catalogue, essay by Alan Solomon].

New York, The Solomon R. Guggenheim Museum. *Abstract Expressionists and Imagists*. October 13 - December 31, 1961, ill.

— *American Drawings*. September - October 1964, ill. [Introduction by Lawrence Alloway; artists statements].

— *Guggenheim International Exhibition 1967, (Sculpture from Twenty Nations)*. October 20, 1967 - Februray 4, 1968, ill. [Introduction by E. F. Fry; extensive bibliography].

— *Systemic Painting*. September 21 - November 27, 1966, ill. [Exhibition and catalogue essay by Lawrence Alloway].

New York, Sidney Janis Gallery. *Recent Paintings by Ellsworth Kelly*. April 6 - May 1, 1965, ill.

— *New Work by Ellsworth Kelly*. March 1 - 25, 1967, ill.

— *Ellsworth Kelly*. October 7 - November 2, 1968, ill.

— *An Exhibition by 7 Artists*. May 1 - 31, 1969.

— *7 Artists*. December 4 - 31, 1970, ill.

New York, The Jewish Museum. *Primary Structures: Younger American and British Sculptors*. April 27 - June 12, 1966, ill. [Exhibition and catalogue by Kynaston Mc Shine; bibliography].

— *Toward a New Abstraction*. May 19 - September 15, 1963, ill. [Preface by Alan Solomon; introduction by Ben Heller; chronology; bibliography].

New York, The Metropolitan Museum of Art. *New York Painting and Sculpture 1940-1970*. October 16, 1969 - February 1, 1970, ill. [Exhibition and catalogue by Henry Geldzahler, with critical essays; individual bibliographies; published as book by E. P. Dutton & Co., New York, 1969].

New York, The Museum of Modern Art. *The Art of the Real "U.S.A. 1948-1968"*. July 3 - September 8, 1969, ill. [Exhibition and catalogue by E. C. Goosen; bibliographies].

— *Recent Drawings U.S.A.* April 25 - August 5, 1956. [Catalogue statements by W. S. Lieberman & Elizabeth A. Straus].

— *The Responsive Eye*. February 23 - April 25, 1965, ill. [Exhibition and catalogue by William C. Seitz].

— *Sixteen Americans*. December 16, 1959 - February 14, 1960, ill. [Exhibition and catalogue by Dorothy C. Miller; artists statements; photographs].

— *Two Decades of American Painting*, ill. [Exhibition organized by department of Circulating Exhibitions, traveled to Far East and Australia; catalogue essays by W. Rasmussen, I. Sandler, L. Lippard].

— *The Nelson Aldrich Rockefeller Collection*. May 26 - September 1, 1969, ill. [Exhibition directed by D. C. Miller; foreword by Monroe Wheeler; preface by Nelson A. Rockefeller; essay by William S. Lieberman].

New York, The Whitney Museum of American Art. *1959 Annual Exhibition of Contemporary American Painting*. December 9, 1959 - January 31, 1960.

— *Annual Exhibition 1960 - Contemporary Sculpture and Drawings*. December 7, 1960 - January 22, 1961.

— *Annual Exhibition 1961 - Contemporary American Painting*. December 13, 1961 - February 4, 1962, ill.

— *Annual Exhibition 1963 Contemporary American Painting*. December 11, 1963 - February 2, 1964.

— *1965 Annual Exhibition of Contemporary American Painting*. December 8, 1965 - January 30, 1966.

— *Annual Exhibition 1966 Sculpture and Prints*. December 16, 1966 - February 5, 1967, ill.

— *1967 Annual Exhibition of Contemporary American Painting*. December 13, 1967 - February 4, 1968.

— *1968 Annual Exhibition of Contemporary American Sculpture*. December 17, 1968 - February 9, 1969.

— *1969 Annual Exhibition of Contemporary American Painting*. December 16, 1969 - February 1, 1970.

— *A Decade of American Drawings 1955-65*. April 28 - June 6, 1965. [Foreward by Donald M. Blinken].

— *Geometric Abstraction in America*. March 20 - May 13, 1962, ill. [Foreward by Eloise Spaeth, essay by John Gordon, chronology].

— *The Structure of Color*. February 25 - April 18, 1971. [Exhibition & text by Marcia Tucker].

Paris, Galerie des Beaux-Arts. *Premier Salon des Jeunes Peintres*. January 26 - February 15, 1950 [French text].

Paris, Galerie Adrien Maeght. *Ellsworth Kelly 27 Lithographies*. June 1965, ill. [Text by Dale Mc Conathy].

Paris, Galerie Maeght. *Ellsworth Kelly*. October 24 - November 1958, ill. [Catalogue in *Derrière le Miroir* Vol. 110, October 1958, pp. 1-16; English/French text by E. C. Goosen].

— *Ellsworth Kelly*. November 20 - December 1964, ill. [Catalogue in *Derrière le Miroir* Vol. 149, November 1964, pp. 3-14; English/French text by Dale Mc Conathy].

— *Tendances*. October 1951. [Catalogue in *Derrière le Miroir* Vol. 41, October 1951; French text].

— *Tendances*. October 1952. [Catalogue in *Derrière le Miroir* Vol. 50, October 1952; text by Michel Seuphor].

Paris, Palais des Beaux-Arts de la Ville de Paris. *Réalités Nouvelles Cinquième Salon*. June 10 - July 15, 1950.

Pasadena, Pasadena Art Museum. *Serial Imagery*. September 17 - October 27, 1968, ill. [Exhibition and text by John Coplans].

Pittsburgh, Carnegie Institute. *The 1958 Pittsburgh International Exhibition of Contemporary Painting & Sculpture*. December 5, 1958 - February 8, 1959, ill.

— *The 1961 Pittsburgh International Exhibition of Contemporary Painting & Sculpture*. October 27, 1961 - January 7, 1962, ill.

— *The 1964 Pittsburgh International Exhibition of Contemporary Painting & Sculpture*. October 30, 1964 - January 10, 1965.

— *The 1967 Pittsburgh International Exhibition of Contemporary Painting & Sculpture.* October 27, 1967 - January 7, 1968.

São Paulo, Museu de Arte Moderna. *VI Bienal: Estados Unidos 1961*, ill. [English/Portuguese texts, foreword by René d'Harnoncourt; texts by F. O'Hara, T. B. Hess, W. C. Seitz].

Seattle, World's Fair 1962. *Art Since 1950 (American and International).* April 21 - October 21, 1962, ill. [Text by Sam Hunter].

St-Paul de Vence, Fondation Maeght. *L'Art Vivant aux Etats-Unis.* July 16 - September 30, 1970, ill. [Exhibition and catalogue by Doré Ashton].

Tokyo, Metropolitan Art Gallery. *The Seventh International Art Exhibition of Japan.* 1963, ill. [Catalogue statement by Tsunetaka Ueda].

Vancouver, Vancouver Art Gallery. *New York 13.* January 21 - February 16, 1969, ill. [Exhibition by Doris Shadbolt; text by Lucy Lippard; photographs of the artists; bibliography].

Venice, Biennale Internazionale d'Arte. *XXXIII International Biennial Exhibition of Art, Venice 1966 U.S.A.* June 18 - October 16, 1966, ill. [Exhibition and English/Italian text by Henry Geldzahler].

Washington, D.C., Washington Gallery of Modern Art. *Paintings, Sculpture, and Drawings by Ellsworth Kelly,* December 11, 1963 - January 26, 1964, ill. [Foreword by Adelyn D. Breeskin; interview by Henry Geldzahler].

Zagreb, American Embassy. *Savremena Americka Umetnost (American Vanguard Exhibition).* 1961-1962, ill. [Slavic/English text by H. H. Arnason].

Design: Marcus Ratliff

Assistant Editor: Jane Salzfass

Photography: Photos in the introduction were taken by Ellsworth Kelly ;
Other photographs by: Geoffrey Clements, New York; Gemini G.E.L., Los Angeles;
The Solomon R. Guggenheim Museum, New York; Malcolm Lubliner, Los Angeles;
Galerie Maeght, Paris; The Museum of Modern Art, New York;
Eric Pollitzer, New York; Nathan Rabin, New York.

First printing completed at Imprimeries Réunies S.A., October 1, 1971.

The original edition consists of one hundred copies printed on
Velin Cuve Rives, signed and numbered by Ellsworth Kelly 1 to 100,
with the lithograph "Blue, Green, Black and Red", 1971,
edition of 100, signed lower right, Kelly, and numbered lower left,
on Arches, printed by Mourlot Graphics Ltd.,
published for the original edition by Paul Bianchini, New York.